IMAGES
of America

FORGOTTEN
COLUMBUS

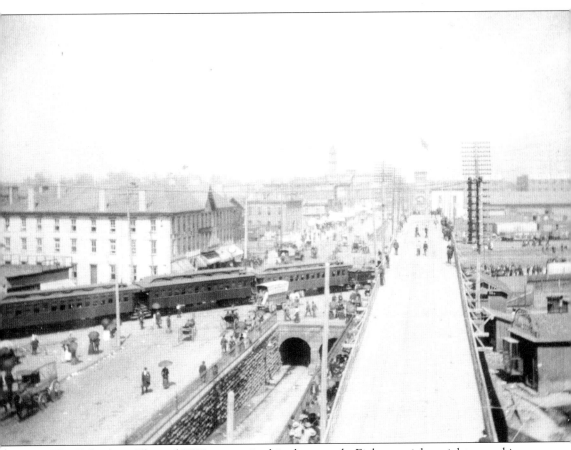

The Columbus, Ohio, of 1888 appears in this photograph. Eighteen eighty-eight was a big year in the capital city; aside from the festivities celebrating the centennial of the settlement of Marietta, the city was overrun with Civil War veterans, in town for the Grand Army of the Republic National Encampment. This photo looks south from North High Street near Union Station. The temporary High Street viaduct had been constructed to accommodate the GAR. The large building at left, the Exchange Hotel or Powell House, would be demolished five years later to make room for the permanent viaduct.

IMAGES
of America
FORGOTTEN
COLUMBUS

Andrew Henderson

ARCADIA

Published by Arcadia Publishing,
an imprint of Tempus Publishing, Inc.
3047 N. Lincoln Ave., Suite 410
Chicago, IL 60657

Printed in Great Britain.

Library of Congress Catalog Card Number: 2002101247

For all general information contact Arcadia Publishing at:
Telephone 843-853-2070
Fax 843-853-0044
E-Mail sales@arcadiapublishing.com

For customer service and orders:
Toll-Free 1-888-313-2665

Visit us on the internet at http://www.arcadiapublishing.com

For my mom,
Mary Elizabeth Henderson

CONTENTS

ACKNOWLEDGMENTS

Without the following people this book could not have been completed.
I thank them for their advice, expertise, and assistance.

The staff at the Columbus Metropolitan Library—particularly the third floor Biography, History, and Travel section. Special thanks to Deborah Rittenhouse, Sam Roshon, Julie Callahan, and John Newman, who provided information on hundreds of old photographs and helped me sort through thousands more. Credit must be given to the Columbus Circulating Visuals Collection, from which many of these photos were borrowed.

Thanks to the Ohio Historical Society and the OHS Library and Archives.

Thanks also to the following:

Larry Henderson
Chris Mershon
Brooke Lafferty
Heidi Hughes
Ryan O'Neill
Melanie Denyer
Alison O'Neill
Dan Eaton
Ed Ewers
Quinn Fallon, and everyone at Andyman's Treehouse

And finally, thanks most of all to Jeff Ruetsche, my editor at Arcadia, for his help, and for giving me the opportunity.

INTRODUCTION

Columbus has always been an odd amalgam of the planned and the spontaneous. First, of course, there was Franklinton—Lucas Sullivant's 1797 frontier settlement on the low bank of the Scioto River. When the wooded plot across the river was selected to be the new capitol, engineers were brought in to draw the city streets. Its official founding in 1812 saw Columbus's birth as a city with a purpose behind its very existence—a planned seat of government much like L'Enfant's Washington D.C. Young Columbus had borders marked by North Street, South Street, East Street, and West Street. It had a Broad Street and a High Street and a Main Street. It had state government buildings, and hotels to accommodate legislators committed enough to make the trek "into the wilderness" from real cities like Toledo, Cleveland, and Cincinnati.

Then immigration started to tug at the neatly squared borders of Columbus. The first large group to do so was the Germans, who settled south of the city's carefully planned streets and built their neighborhood in homage to the country they had left behind, filling it with tall German-style brick houses and narrow cobblestone alleys. The Italians built their homes north of the city. Others came—Polish, Irish, Hungarian. They formed communities, built homes, found work.

In 1870, Columbus annexed Franklinton. The original border streets lost their meanings and their names. Erosion and the placement of the flood wall would put West Street under the river, and South Street would be torn out when Interstate 70 cut its way through town. Columbus's borders had begun an expansion which has not slowed to this day.

Meanwhile, the central city was being shaped by necessity and innovation. The final decades of the nineteenth century and first of the twentieth saw tens of thousands of Columbus citizens go to work in the newly established business and manufacturing districts. They built mining implements and shoes, caskets and buggies. They brewed beer and milled steel. They served their country at Fort Hayes and the new Air Force Base in Lockbourne. They attended college at the State University on Neil Avenue.

Things changed. Manufacturing fell off and there were retail booms. Downtown shopping declined and fast food took off. The Ohio Penitentiary deteriorated while the Ohio State University built state-of-the-art research facilities and became an athletic powerhouse.

Today Columbus, though still a young city by many standards, has become a national contender. It has also become the state capital in more than title alone, boasting more residents

than either Cincinnati or Cleveland. While the past five decades have seen residents leave these two cities in record numbers, Columbus's population has yet to decline. It remains a healthy gap in the Midwestern Rust Belt.

As a city with a vibrant economy, Columbus has left much of its past behind. New housing developments overtake farm fields on the edge of town while old neighborhoods and industrial areas fall to the wrecking ball and are replaced with new stadiums, malls, and commercial districts. Today not a single building from the original Franklinton still stands.

This book takes a look at some of the forgotten sights of old Columbus. In many cases the places shown in these pages no longer remain in any form. A lucky few have been renovated and are still in use. Many stand abandoned, or did for many years.

I hope you enjoy this look at Columbus in the years before Easton, professional hockey, and Victoria's Secret.

One

THE OLD OHIO
PENITENTIARY

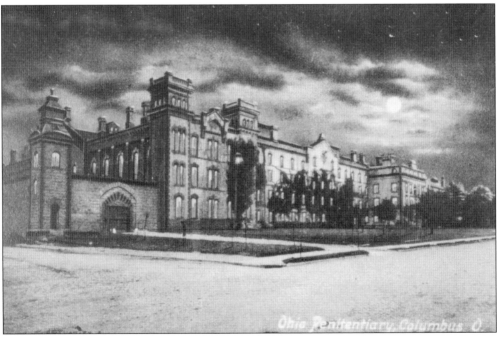

The Ohio Penitentiary stood on West Spring Street for 164 years, from 1834 to 1998. Even before the Spring Street building was constructed, being "sent to Columbus" meant hard time for anyone convicted of a crime in Ohio. In spite of the frequently tragic events which transpired inside its walls, the "Pen" became a local landmark as easily identifiable with Ohio's capital city as the statehouse or the Broad Street Bridge.

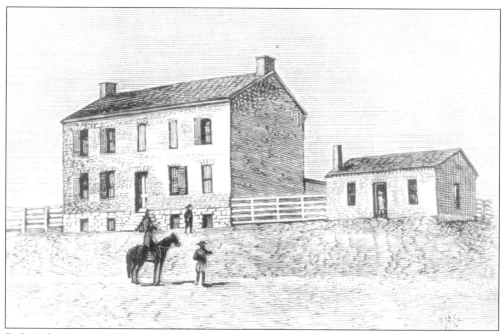

Before the State Pen was on Spring Street, it occupied this unassuming building and several others at 139 West Mound Street. The original penitentiary operated between October 15, 1815, and October 27, 1834, when the prisoners were marched to the new building. A 1909 history described the conditions at the old prison as less than desirable: "The mortality was great and the pardons numerous. Of the 150 prisoners received during the first five years not less than 82 were pardoned, and of the remaining 65, 11 died." One prisoner out of every ten at the original Ohio Penitentiary succumbed to what must have been remarkably cruel treatment.

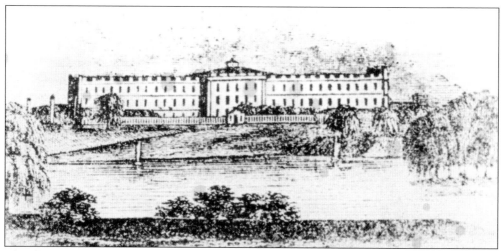

This drawing by Henry Howe shows the main Pen building as it appeared in 1846, just twelve years after its construction. Prison labor from the original penitentiary was used in the construction project. The Annex and other buildings would be built over the course of the next hundred years, expanding the prison's grounds along the Scioto River and creating the more familiar peaked facade.

More than any other one person, Warden Elijah G. Coffin was responsible for bringing the Ohio Penitentiary to national prominence in the years leading up to the twentieth century. During his two terms as warden (1886–1890 and 1896–1900) he instituted military-style regulations while also implementing progressive policy changes. Prisoners were allowed more freedom in their recreational time, but were required to keep neat cells and line up efficiently when moving in groups. The spectacle this created made the Pen a popular tourist destination during his tenure. Coffin, who died in 1910, is shown here at the beginning of his second term as warden.

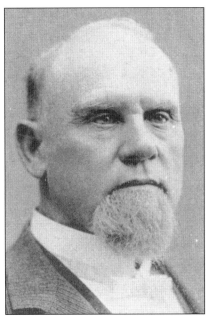

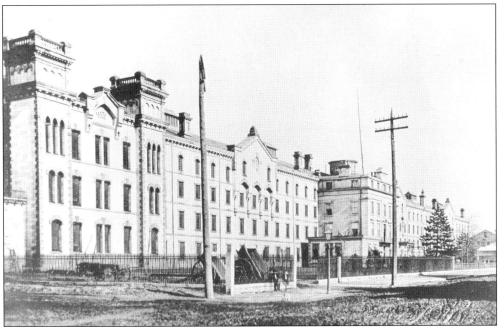

By the turn of the century, the Annex had been constructed, but the city streets were still made for horses and largely unpaved. A hard rain could make them impassable. There were still tree stumps in the middle of High Street when the first automobiles appeared in Columbus. The provincial setting belied the Pen's status as a territorial prison, taking in federal prisoners from all over the United States. It was in its capacity as a federal penitentiary that the Ohio Pen received such diverse prisoners as "vampire" James Brown, who killed one of his shipmates in the Indian Ocean in 1866, and then drank his blood; Dillinger cohorts Charles Makley and Harry Pierpont; and William Sidney Porter, better known as author O. Henry. Porter wrote the Christmas classic "The Gift of the Magi" behind these walls.

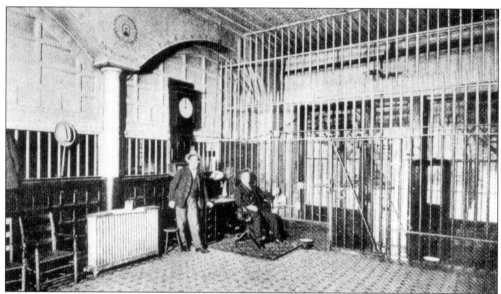

This is the first sight which greeted new inmates once they were inside the walls. Prison workers in the Guard Room, also known as the "Bull Pen," would put them through the admissions process, which involved heavy paperwork, as well as delousing and a strip search. From here prisoners were taken to an examination room, where their Bertillon measurements were taken for addition to their files. In 1909, the Ohio Pen was using this pre-fingerprinting identification system, developed by the French doctor Alphonse Bertillon. A taking of the Bertillon measurements could take up to an hour, and involved precise measurements of dozens of physical features, including the length and width of the head; cheek width; foot size; finger lengths; height, both standing and seated; and a complex classification of the "ear type."

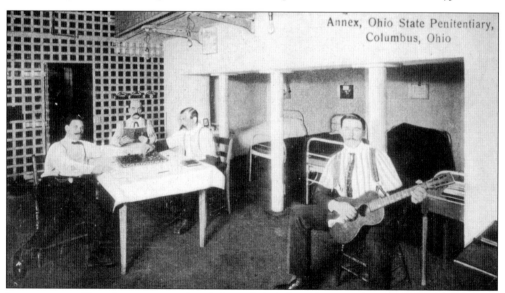

Inmates were allowed some recreational time while behind bars, as this 1910 photograph from the prison annex shows. One man plays his guitar in the recreation area while two others play a board game behind him and a third reads. Long Ohio winters necessitated the indoor recreation rooms for times when the exercise yard was rendered unusable by cold or snow.

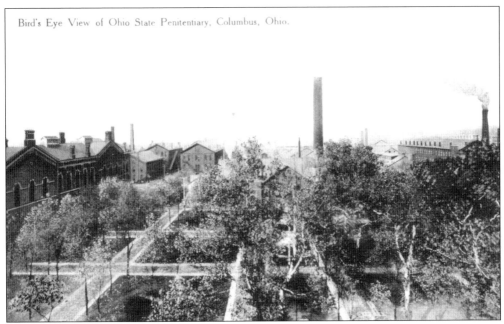

A 1910 aerial view of the prison grounds is shown above. The buildings in the back row are mechanical shops. While incarcerated, a convict might be assigned to any number of these departments for work, including the textile plant, print shop and bindery, bolt works, cigar factory, broom shop, stove factory, stamp shop, soap house, or the hoe, rake, and snath shop. There was even an "idle house" for offenders too crippled or deformed to hold productive jobs. The less unfortunate among the "idlers" were sometimes employed as vegetable peelers for the kitchen.

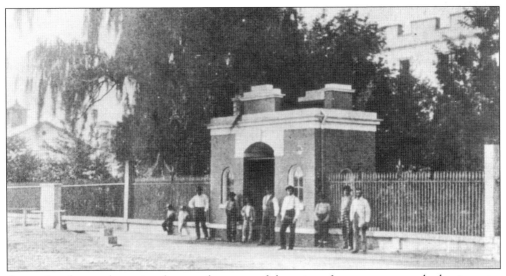

A guard and several convicts lounge along one of the prison fences near an arched entry gate. The inmates are distinguishable by their striped pants. They are most likely posing for the photographer; a scene like this probably wasn't a common sight along Spring Street in the early 1900s.

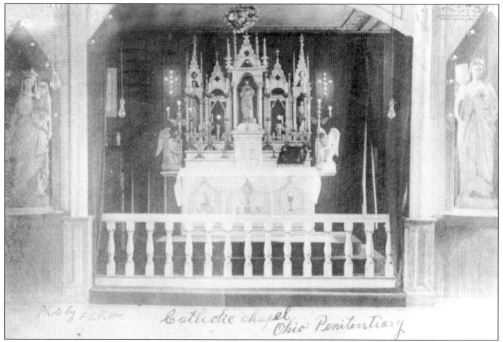

Guests of the Penitentiary were strongly encouraged to practice their religious faith during their stay. This chapel was just one of several in the prison. Priests, ministers, and rabbis were always available to inmates with a desire to leave their sinful ways behind.

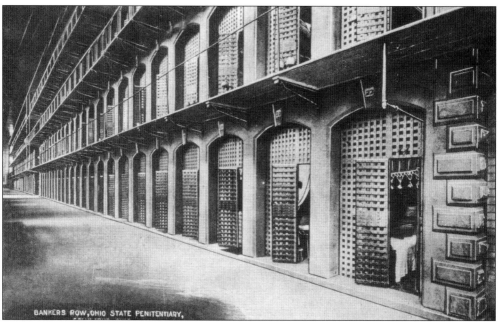

The cells in the block pictured above were known as Banker's Row, and were a source of resentment and hostility at the Pen. The white collar inmates housed here enjoyed better treatment than the general population. The living conditions on Banker's Row, which often included a private cell, were also a cut above those of the average inmate.

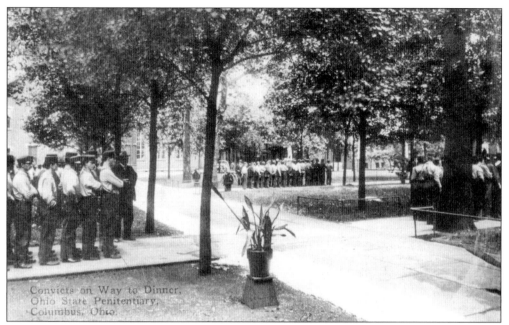

Inmates line up for meals in this 1910 photo. The military-style lineup was one of the methods introduced by Warden Coffin, and this photo is of the sort which sightseers could have purchased during one of the frequent tours of Coffin's Ohio Penitentiary.

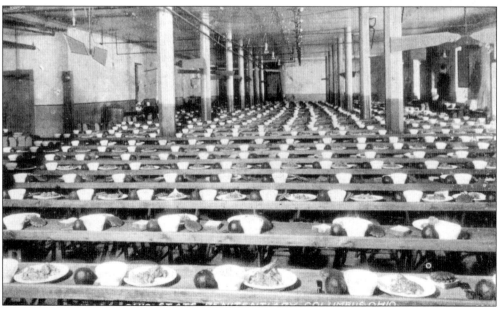

The dining hall is shown here equipped for a meal. The bowls and plates were fastened to the long row tables, giving the dining area its even, orderly appearance. The room was L-shaped, and had a capacity of two thousand. Inmates ate in shifts and were served where they sat.

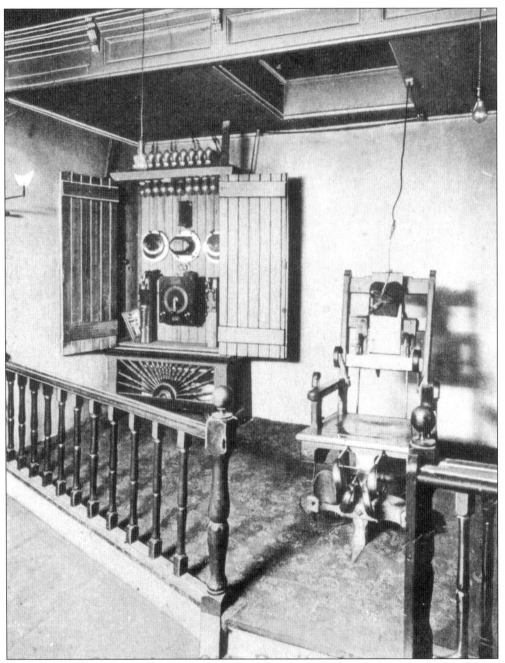

The electric chair is shown off here in its home in the Penitentiary Annex. According to legend, the chair was situated directly beneath the trap of the old gallows, where executions were conducted until the induction of the electric chair in 1897. The chair's first victim was William Haas, a rapist-murderer from Hamilton County who died April 21, 1897. The last execution in Ohio for more than thirty years was conducted in the Ohio Penitentiary's electric chair, when Donald Reinbolt was put to death on March 15, 1963. The women's building featured its own electric chair; executions were carried out there until female inmates were transferred to the new women's prison in Marysville in 1913.

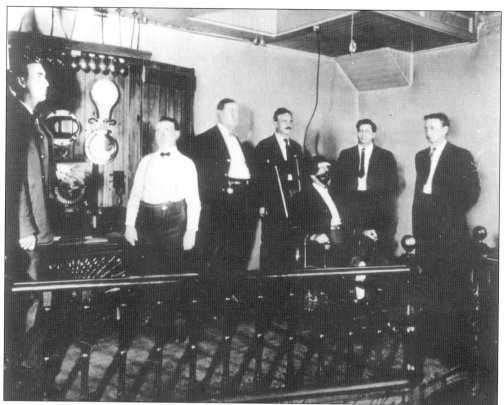

"Old Sparky" is exhibited here by prison employees. Despite its morbid nature, the death chair was in many ways the pride of the prison, and it was put to heavy use up until its 1963 retirement. All told, 315 human beings died in its seat. A stop at the Annex was the most eagerly anticipated part of a tour of the prison. People's fascination with the chair hearkens back to the days of public hangings in downtown Columbus, which brought spectators in from all over the state.

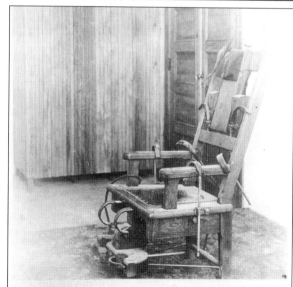

The first electric chair at the Ohio State Penitentiary believed to be the first used anywhere for electrocution

An extremely dubious claim appears on this souvenir card. The first legally sanctioned execution by electrocution actually took place on August 6, 1890, at Auburn State Prison in New York State. Columbus electrocutions wouldn't commence for another seven years.

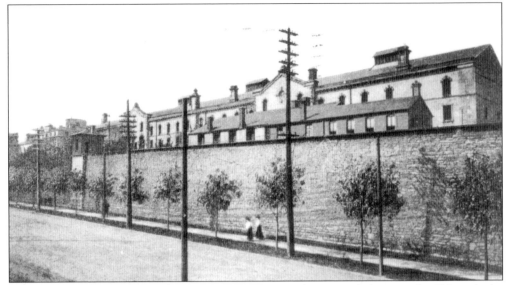

Here we see the wall of the Ohio Penitentiary in an early postcard photograph. Although the walls were high and sunk several feet below the surface, at least fifty escapes were successfully executed during the prison's century-and-a-half of operation. The most famous was that of Confederate General John H. Morgan, who chiseled through the floor of one of his men's cells and escaped via an air chamber beneath the block on November 26, 1863. With six others, Morgan climbed the wall with the help of a rope and grappling hook and fled back to the South, where he was hailed as a hero for his daring raid the northern states. In 1908, burglar Walter Edward White made it over the wall using a pole and a rope made out of bed sheets. White's was the last successful escape attempt to go over the wall.

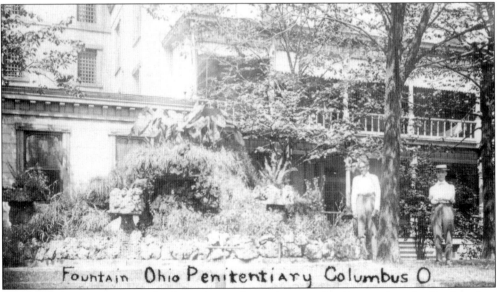

Fountain Ohio Penitentiary Columbus O

Prison employees pose near the fountain on the main grounds. At one time the Penitentiary grounds were considered very attractive, but over time industrial facilities took the place of the garden and field. One thing which did remain was the exercise yard, which was later named O. Henry Field in honor of the Pen's most famous literary alumnus.

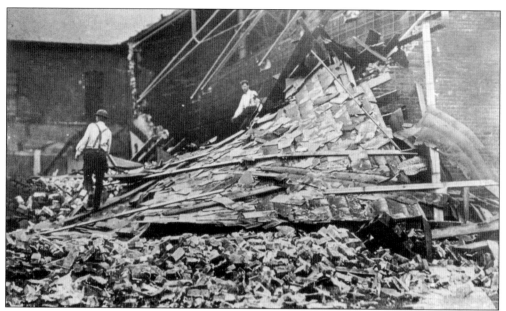

In 1929, a tornado heavily damaged the Ohio Penitentiary. This photo shows prison workers surveying some of the damage done to an industrial building.

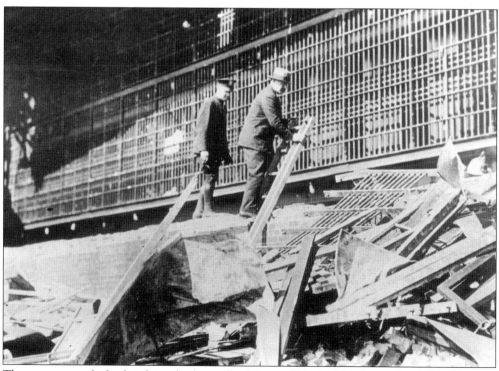

The same tornado broke through the wall of this cellblock. The bars of a walkway in the evacuated block are visible behind the workers. This disaster was a harbinger of the much more severe Pen Fire, which would occur only a year later.

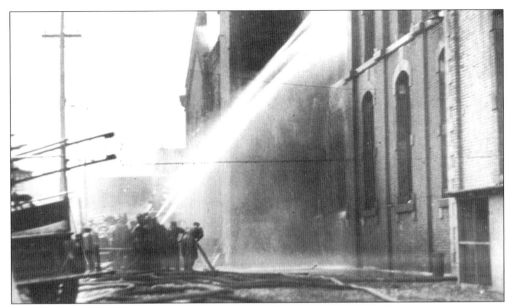

On April 21, 1930, three inmates placed a candle stolen from the chapel on a floating block of wood in a pan of kerosene, planning to make their escape when the fire broke out at mealtime. The fire, however, didn't erupt until an hour later, when prisoners were locked back in their cells. The wood-and-tarpaper roof—the only part of the prison not fireproof—burned with toxic fumes that flowed through the open attic into G and H blocks, where inmates trapped in their cells perished by the hundreds. The final toll would be 320 dead. After the fire at the Pen, angry prisoners took over the "White City" cell block. This photo shows prison guards using high-pressure fire hoses in an attempt to flush them out. The prisoners were eventually fired upon by guards, but it took the National Guard to force them to vacate White City—which by then had been thoroughly trashed.

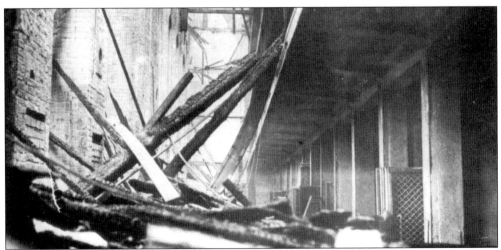

Although the death toll was high, damage to the Penitentiary itself during the 1930 fire was relatively meager—only about $11,000—and was done mostly to the roof. Prisoners were released from their cells, and several were later commended for their efforts to save lives; many used fire axes to smash the locks off cell doors, and one man died after carrying eleven others to safety. Only one escape was attempted that night. Here the aftermath is shown; the sky is visible where the ceiling once was, and the charred rafters from the highly flammable roof have fallen into the cell block.

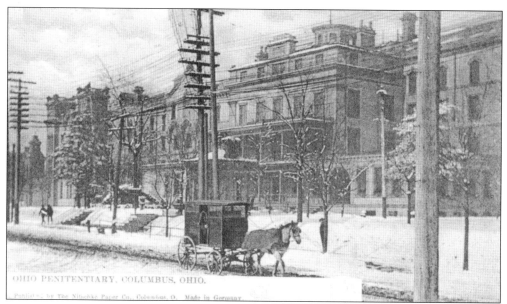

A charming 1907 winter scene is shown on this postcard. At this time, the Penitentiary was part of the riverfront and often included in tours of the city. In ensuing decades, events such as the 1930 fire and the August 1968 riots, in which nine guards were taken hostage and five inmates died, hurt the Pen's image. The fact that the industrial buildings were allowed to deteriorate after the riots gave it a reputation as an outdated, decrepit building.

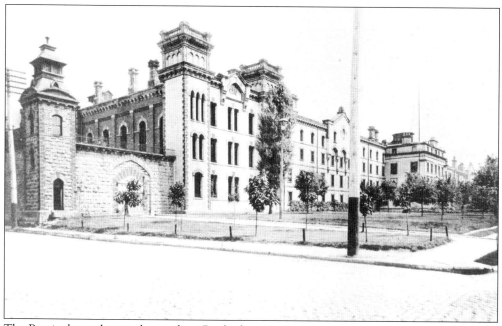

The Pen is shown here in better days. By the late 1970s, it had become a disaster area. In 1979, Judge Duncan ordered it closed by December 31, 1983. After an eight-month delay the last prisoners were finally removed from the old Penitentiary in August 1984. Most were sent to the Ohio State Reformatory in Mansfield. For the first time in 150 years, the Ohio Penitentiary stood empty—and, according to local legend, haunted.

21

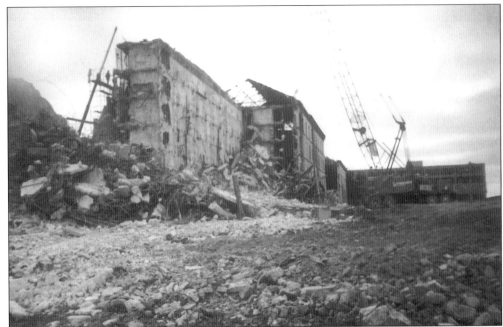

In March of 1997, fifteen of the Ohio Penitentiary buildings fell to the wrecking ball. It would be another year before all vestiges of the Pen were finally removed. Shown in the next four photos is the final demolition of the main Penitentiary building on Spring Street in January of 1998. The pictures appear courtesy of Ryan O'Neill and Melanie Denyer.

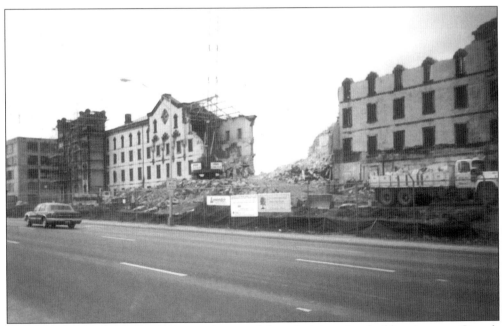

Here the roof has been knocked in and most of the administration building is gone. Crowds gathered to say goodbye to the Pen, and many took pieces of the walls home as souvenirs; newspapers reported on some who built patios and fireplaces from the bricks which originally made up the Penitentiary wall.

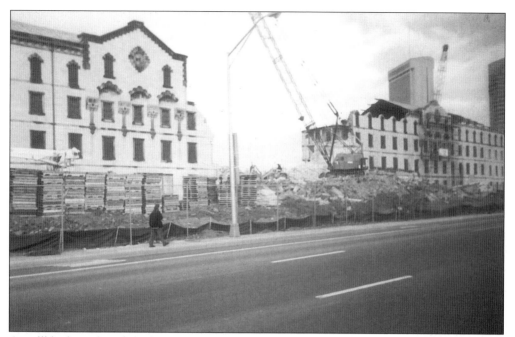

A cellblock is demolished in this photo; the floors and individual cells are visible. The scaffolding at right had been used to take out any window glass and remove decorative fixtures for possible inclusion in local historical exhibits.

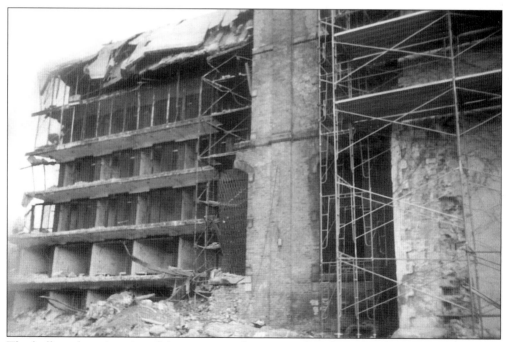

The hollowed-out interior of the prison can be seen in this photo. By the time night fell, the entire building had been reduced to rubble, demolished to make way for the Arena District surrounding Nationwide Arena, home to the NHL Columbus Blue Jackets. Today a hockey stadium parking garage stands where Ohio's worst criminals were housed for 150 years.

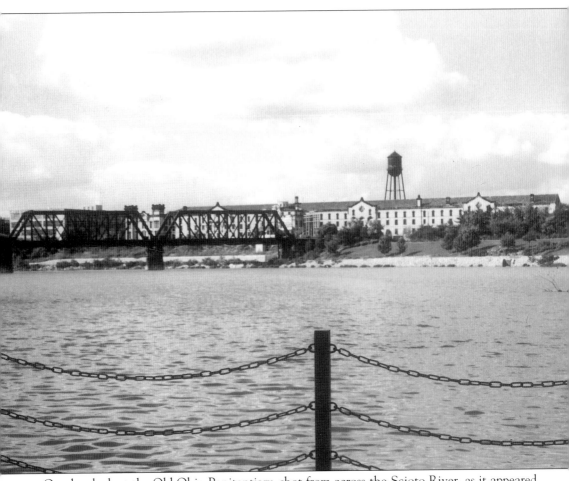

One last look at the Old Ohio Penitentiary, shot from across the Scioto River, as it appeared in its final days, c. 1996. (Photo courtesy Alison O'Neill.)

Two
THE HARTMAN EMPIRE

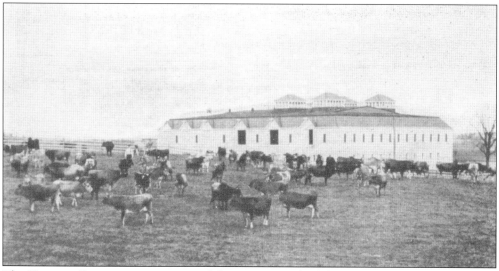

The Hartman Farm was just one part of the vast empire built by Samuel Brubaker Hartman in the 1890s. The farm quickly gained fame nationally, even claiming to be "the largest functioning farm in the world." Shown here are his cattle, grazing in the pasture near one of Hartman's signature white barns.

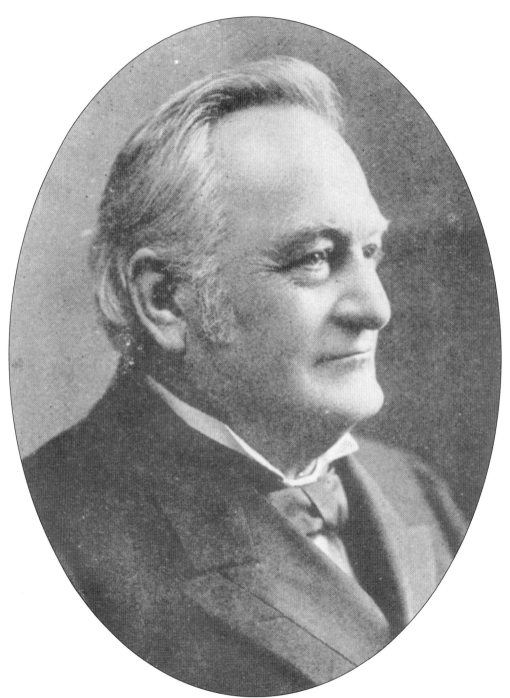

Dr. Samuel Brubaker Hartman, the Les Wexner of the Gilded Age, was the head of an empire worth $2.25 million in 1918. Hartman was born in 1830 on a Pennsylvania farm and worked his way through medical school at the Cincinnati Farmer's College by selling German Bibles to immigrants. In 1890, he abandoned his medical practice to produce a patent medicine of questionable benefit called Peruna. Peruna made Hartman rich and enabled him to build an empire which would help define Columbus business and culture for much of the twentieth century.

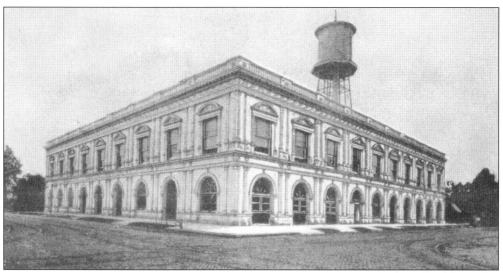

Peruna, Hartman's "neutralizing mixture," was manufactured at the Columbus plant shown above. It had originally been manufactured at Hartman's brother's home near Dayton. Although touting it as a medicine and cure for "catarrh"—a disease of the bodily fluids—made him a millionaire several times over, Peruna was in fact as much as 28 percent alcohol.

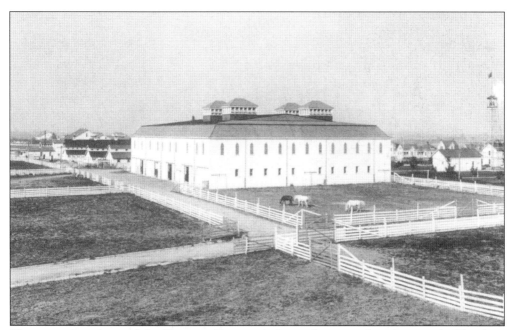

The main dairy barn of the Hartman Farm complex is shown in this photograph. The farm spread over hundreds of acres several miles south of Columbus along Route 23, between the place where I-270 crosses South High Street today and the Pickaway county line.

Pseudoscience and medical quackery were at their best (or worst) when Dr. Hartman lectured on his scientific theories. When confronted with a list of the ingredients used in Peruna, which consisted of cubebs for flavor, burnt sugar for color, and pure grain alcohol, Hartman's defense was that few medicines actually addressed any particular ailment, but the slight stimulation provided by Peruna, combined with the positive state of mind inspired by the testimonials of other patients, would be conducive to healing. Later in life he eschewed writing and lecturing in favor of managing his thriving business.

The "Lucky Day" Almanac was just one of the marketing tools used to move Peruna. Marketing genius Frederick Schumacher was largely responsible for the product's success, organizing million-dollar advertising campaigns and making crucial decisions as seemingly insignificant as dropping the hyphens from what Dr. Hartman preferred to call Pe-Ru-Na. Schumacher had married Hartman's daughter and quickly rose to the position of vice president and director of advertising.

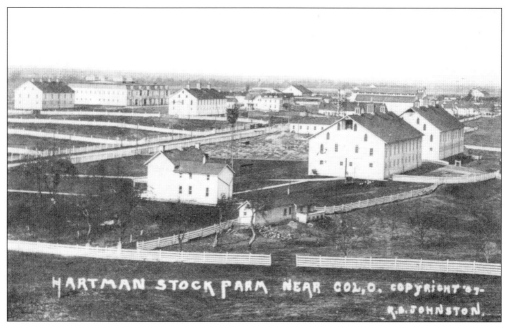

Shown here is another view of the Hartman Farm's white barns, 1907. The dairy farm housed there was famous nationally for milk and beef production, and probably had something to do with the establishment of Columbus's reputation as a "cow town." It was in these fields in 1917 that Dr. Hartman contracted the case of pneumonia which would eventually kill him.

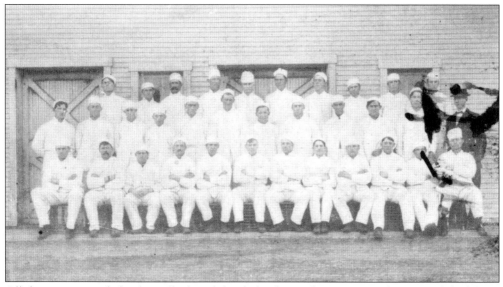

All those cows needed to be milked, and that helped to make Hartman's farm one of the largest employers in turn-of-the-century Columbus. Here the milking crew assembles for a group photograph. The size of the operations made the farm a curiosity to local people, many of whom had grown up on family farms, and photos like this were meant to show off the Hartman Farm's capabilities.

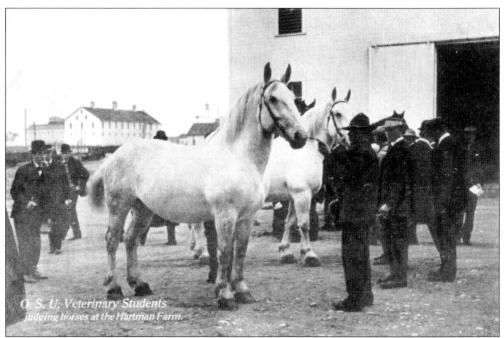

Ohio State University veterinary students judge horses at the Hartman Farm. Hartman's stables, like his dairy farm and chicken stock, attracted worldwide attention. OSU students often traveled south to use his horses as a training opportunity—an arrangement which benefited Hartman as well. Today you'll find Scioto Downs near the place where the stables once stood.

Although in its time the Hartman Farm was located several miles outside the city limits, a trolley line was established between the farm and the south side of Columbus. This was important to the success of the farm in an era when automobiles were still a novelty. Here a trolley car passes farm employee housing on a trip between its two destinations.

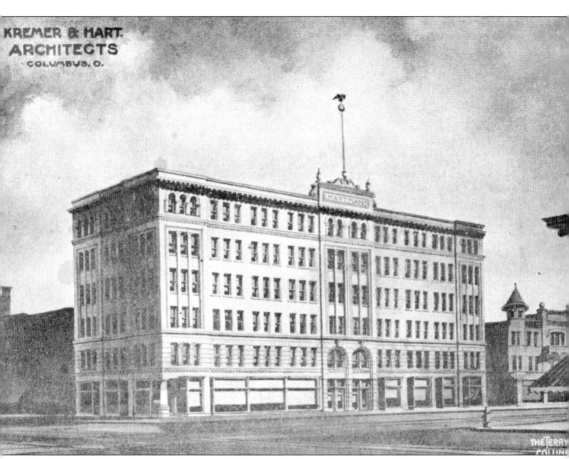

The Hartman Hotel, shown here in 1908, was built at the corner of Fourth Street and East Main in 1898. It was originally intended to house patients of the Hartman Sanitarium, which stood a block north, across Cherry Street. The ornate dining room and ballroom quickly gained a reputation of their own, and Hartman's Hotel went on to outlive his Sanitarium. Hartman himself preferred his family living quarters here to his $100,000 home, and died here from pneumonia in 1917. When the hotel closed in 1921, the state leased the building for government offices, including one of the earliest headquarters of the Bureau of Motor Vehicles.

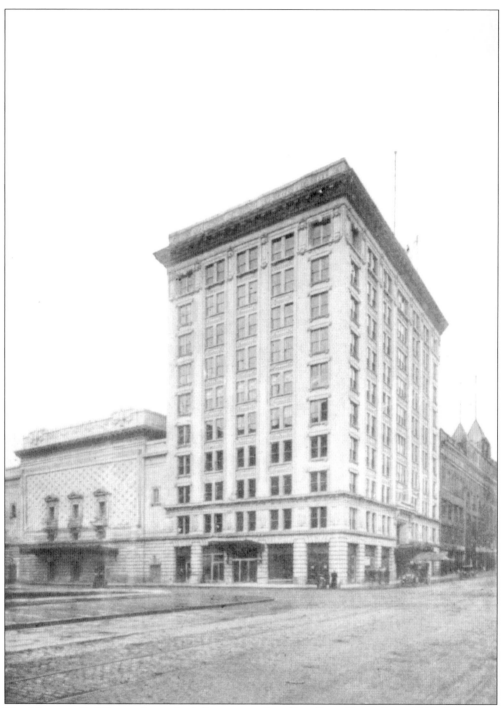

The Hartman Building and attached theater stood on East State Street from 1911 through its demolition in 1971. The Hartman Theater was a major venue for concerts, theater, and movies, and was the theater selected for the world premiere of Eugene O'Neill's play *A Moon for the Misbegotten* on February 20, 1947. Today the offices at Capitol Square stand at the old Hartman Building and Theater site.

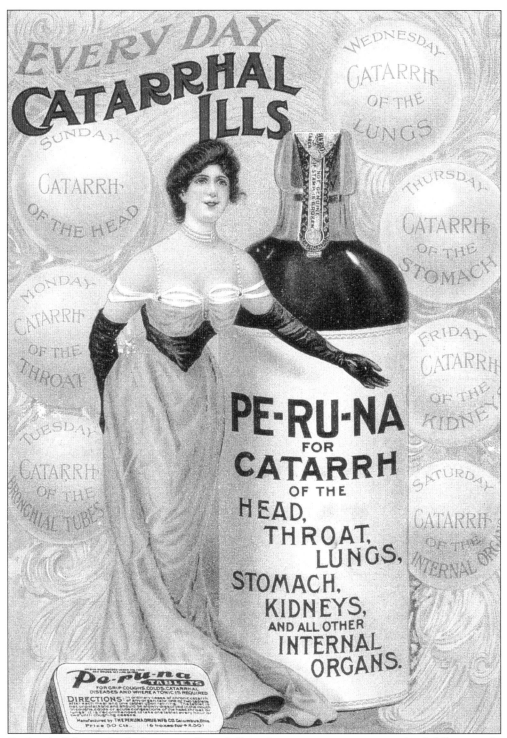

Frederick Schumacher's famous million-dollar advertising campaigns involved full-page ads, such as these. The supposed medical benefits of Peruna are on display in this ad, which boasts of its ability to cure "catarrh" of all parts of the body.

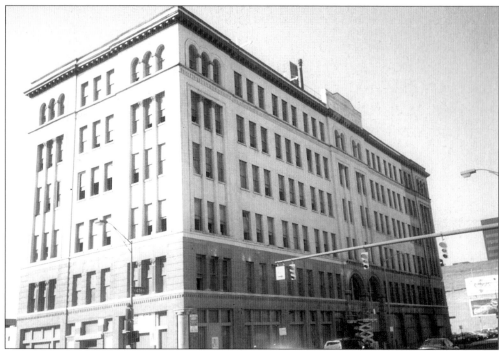

The Hartman Hotel is pictured here in 1999, shortly before its renovation. At the time the next four photos were taken, workmen were setting up to transform the building from the abandoned warehouse it had been into a modern office complex.

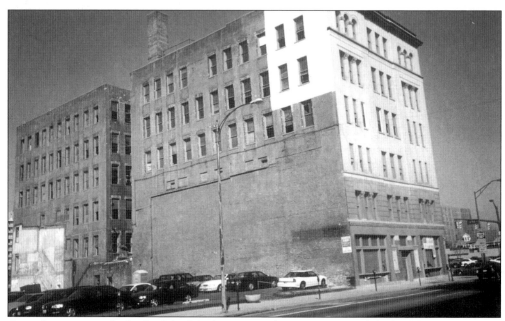

An indentation in the back of the hotel separates the two sections of the building where a fire escape once was. It was replaced and enclosed in glass as part of the renovation. The building was also sandblasted and repainted; at this time the paint in the upper right and bottom left still showed places where other buildings had occupied the block over the years.

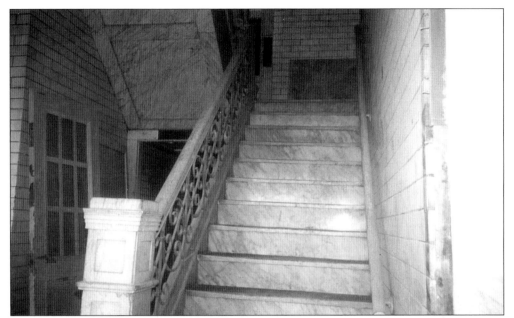

The last occupant of the hotel was a Huntington Bank which vacated in 1995, leaving numerous reinforced safes on the first floor and in the basement, although it didn't occupy anything above the second floor. This photograph shows the ornate marble staircase near the top of the building, which still reflects the Hartman's former grandeur.

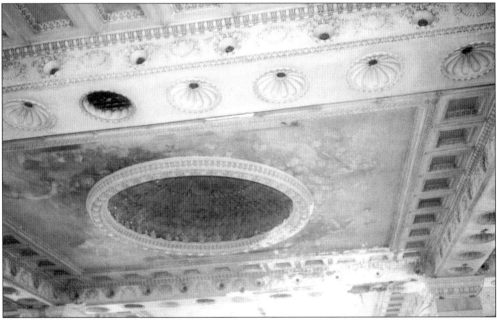

Finally, the elaborate ballroom ceiling peeks through the tiles on the sixth floor of the Hartman Hotel. The south wing of this floor was once the entertainment lounge, featuring dining and dancing. Later in the life of the building the ceiling was covered up by tiles and the room was divided into offices. The ceiling was damaged by a fire in 2000, shortly before the renovation project was complete.

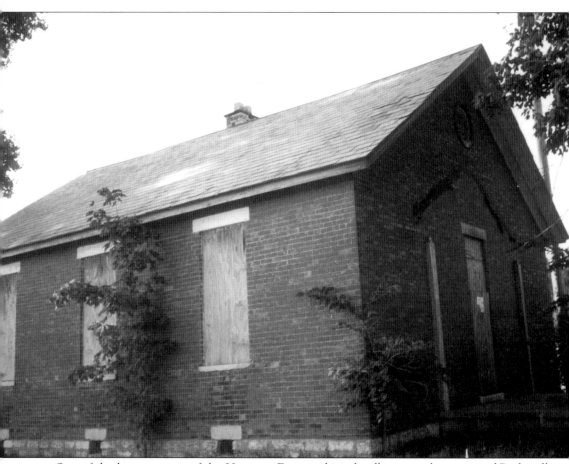

One of the last remnants of the Hartman Farm is this schoolhouse at the corner of Rathmell Road and Route 23 South. When the farm was in operation it functioned as a school for employees' children, but was later left to an employee, who turned it into a home and lived there for several years. It has stood vacant ever since his family moved out. This photograph was taken in April 1999.

Three
THE BREWERY DISTRICT

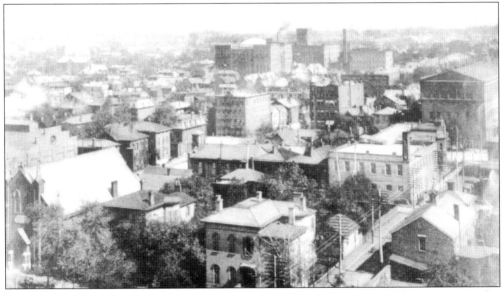

The industrial section of North Fourth Street is shown here at the turn of the century. By this time, the German immigrants who made up much of the Columbus population had transformed the city in innumerable ways. They organized the most distinctive neighborhood in Columbus on the south side, replicating the cobbled streets and narrow houses of neighborhoods in Munich and Dresden. And they began to pursue their individual American dreams—many by starting businesses of their own. For a large number of them, this meant brewing beer. They built their breweries on the western edge of German Village, creating a neighborhood which would retain the name they gave it long after the last brewery there fell to the wrecking ball.

Nicholas Schlee was one of the first brewers in old Columbus. A native German, he was born in 1836, and came to Ohio at the age of 24. For 15 years he operated Schlegel's Bavarian Brewery; then, in 1875, he opened his own firm, the Schlee Brewery, which would later merge with the Hoster-Columbus Associated Breweries. A prominent local businessman, Schlee was also vice president of the Central Bank and the owner of the Lyceum Theater.

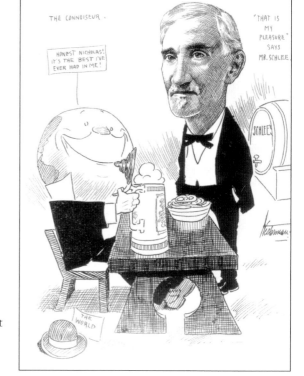

This cartoon shows Nicholas Schlee serving "the connoisseur"—the world—his finest brew. This reflects a public sentiment far removed from that which would lead to Prohibition and the death of many Columbus-area breweries.

The Born family was perhaps the largest clan of brewers in Columbus. Conrad Born Jr., pictured here, was the son of German immigrant Conrad Born, who came to Columbus in 1839. The elder Born worked as a butcher and then a real estate broker—a job which led him to found the Born Brewery in 1859. His son was born in 1844. Conrad Born Jr., followed in his father's footsteps, fully taking over the reins of the Born Company after his father's death in 1890.

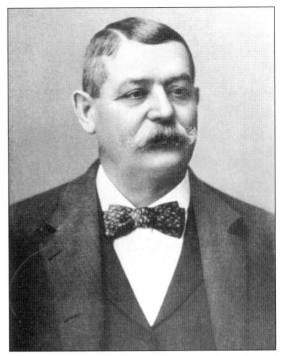

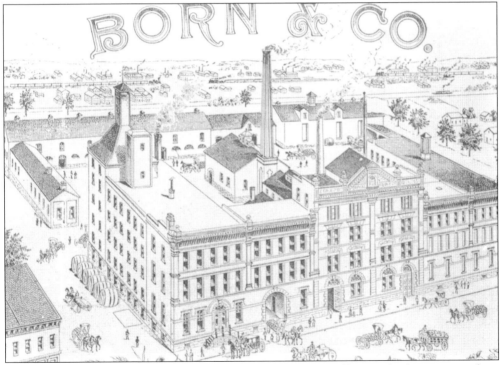

The operations at Conrad Born's brewery are shown in this illustrated advertisement from 1890. The Born Company operated this facility at 449 South Front Street from 1859 through 1904. When it opened it was equipped with a 2,500 gallon cauldron, custom made for the brewery by Deckenbaugh and Co. of Cincinnati.

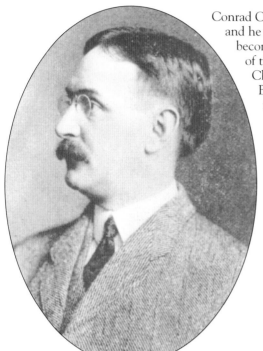

Conrad Christian Born was Conrad Born Jr.'s, son, and he too followed in his father's footsteps to become a third generation brewer. By now most of the work was administrative. Conrad Christian Born oversaw the dissolution of the Born Company in 1904, and served as manager and vice president of the Hoster Columbus Associated Breweries when it was formed the same year. He was also director of the Columbus Malleable Iron Co.

The vine which Conrad Christian Born tends in this cartoon represents the Hoster Columbus Associated Breweries, and includes the three biggest local firms: Schlee, Born, and Hoster. Even after the Born Company's operations were incorporated, the Born family name continued to be synonymous with brewing.

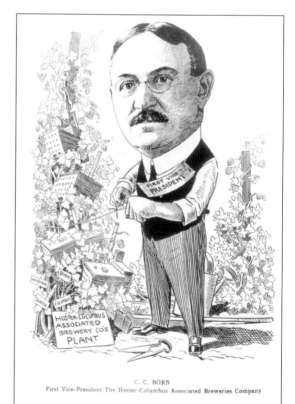

C. C. BORN
First Vice-President The Hoster-Columbus Associated Breweries Company

Yet another member of the Born family, Conrad Edward Born was the last surviving member of the clan to work in the brewing business—as a manager of the Hoster Columbus Associated Breweries. A prominent local businessman, he was also president of the Century Discount Company. He died in 1953.

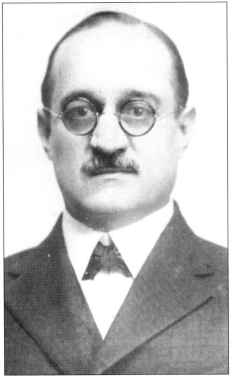

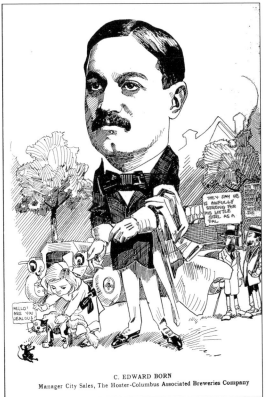

C. EDWARD BORN
Manager City Sales, The Hoster-Columbus Associated Breweries Company

Conrad Edward Born is represented in this cartoon as a society figure in a fashionable suit and tie, but with his little girl nearby. The men in the background comment favorably on him, reflecting Born's clout locally as a wealthy businessman. Less than a century earlier Conrad Born had come to Columbus a poor butcher.

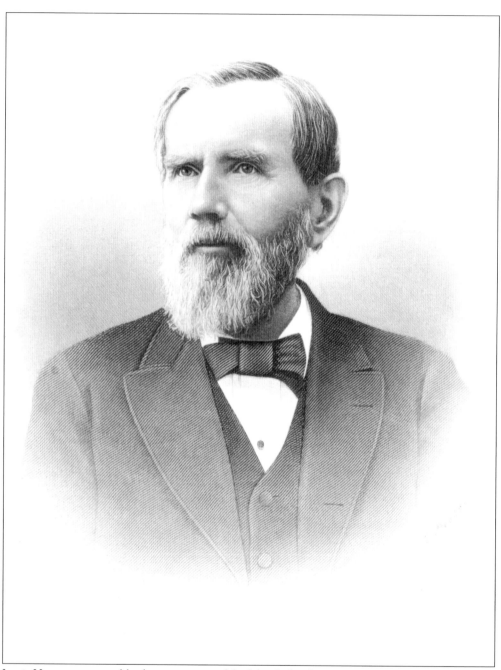

Louis Hoster was arguably the most successful of the Columbus Brewers. Born in 1807, he came to Columbus in 1835, and founded the City Brewery just one year after his arrival. He was a city councilman from 1846 to 1854; two years before he stepped down he started Columbus's first woolen mill on West Mound Street. But it was as a brewer that Hoster found the most success; in August of 1864, he established the Louis Hoster and Sons Brewery, which operated profitably for the remainder of the nineteenth century. In 1904, he co-opted his competition and formed the Hoster Columbus Associated Breweries. Only national Prohibition would end the Hoster family's brewing success in central Ohio.

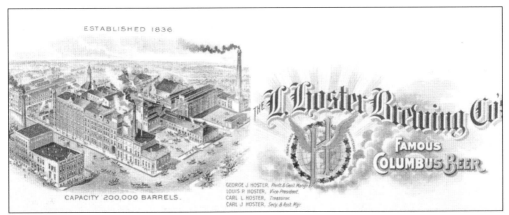

The Lewis Hoster Brewing Company is shown in this advertisement from 1904. By this time, Hoster's sons had taken over nearly the entire business. The plant shown in the ad stood at 477 South Front Street and operated for almost a hundred years, from its 1836 founding as the City Brewery to its shutdown in 1919. That year Congress passed the Volstead Act, superseding the veto of President Wilson and ushering in the era of national Prohibition that killed the brewing business in Columbus as well as the rest of the country.

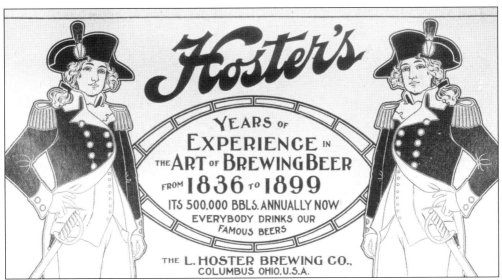

"Everybody drinks our famous beers": An ad for Hoster's from 1899 appears above. Hoster's touts its half-million barrels of annual distribution in the ad, which appeared in taverns and painted on brick buildings at the turn of the century, but production would cease completely in 1919. Only giants like Busch and Coors would be left when Franklin Roosevelt repealed Prohibition on December 5, 1933.

Pictured here is Louis Philip Hoster, one-time vice president of the Lewis Hoster Brewing Company. He became the first superintendent of the Hoster Columbus Associated Breweries in 1904, as well as president of the Columbus Structural Steel Company.

Carl L. Hoster was treasurer of the Hoster Columbus Associated Breweries and also the owner of the landmark Chittenden Hotel at 205 North High Street. This photograph was taken in 1909; Carl L. Hoster moved to California in the 1920s.

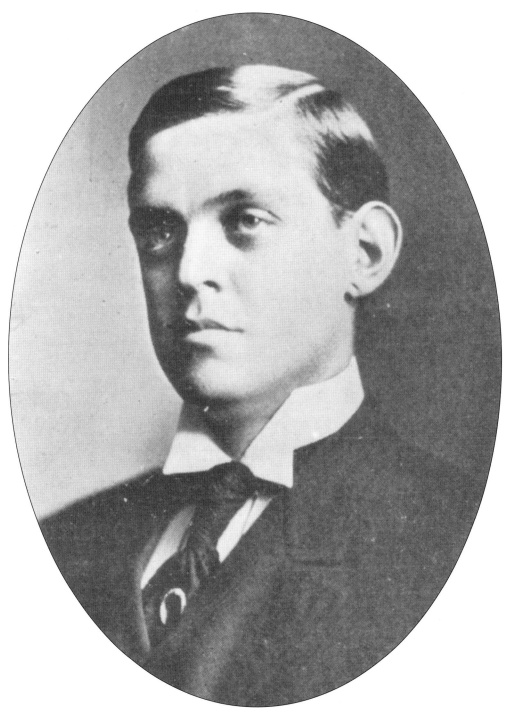

Carl J. Hoster, shown here in 1906, was born in 1873, and was the last surviving member of the Hoster family when he died on All Hallow's Eve, 1941. In addition to his work as president of the Hoster Columbus Associated Breweries, he served as a director of the Hayden Clinton National Bank and the Columbus Driving Park Association. His father, George J. Hoster, was married to Mary Sheldon, who was an aunt of President George Bush.

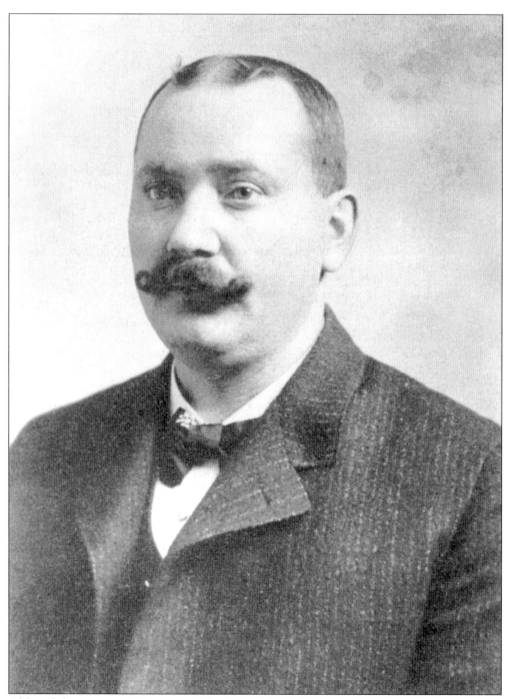

Although he never owned or operated a brewery himself, Charles L. Resch was an important figure in the history of the Brewery District. He worked for the Capital City Brewing Company from 1893 to 1896; the year he left Capital City he opened his own restaurant and tavern. Years later, in 1913, he was elected Sheriff of Franklin County, an office which he held until 1917. He later worked as a sales manager for three different Columbus breweries: Waldo O. Wade, August Wagner, and the Ohio Brewing Company.

Beer wasn't the only beverage put into bottles in the Brewery District. The Coca-Cola Bottling Works opened at 589 South Front Street in 1905, and bottled Coke there until 1948. Today the Coke plant is located on Twin Rivers Drive in north Columbus. This photograph dates to 1906.

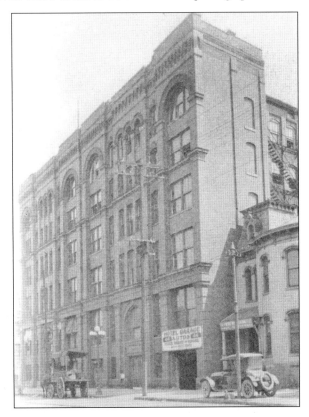

Manufacturing was a constant presence in the Brewery District throughout the years, and when Prohibition killed the breweries themselves it took their place. The Scioto River became heavily polluted by industrial dumping in the following years. This 1919 photograph shows the Ramey Manufacturing Company at 44 South Front Street. Ramey began making its Rayvac Electric Cleaner at this plant a year before selling booze became illegal, and remained in operation through 1972.

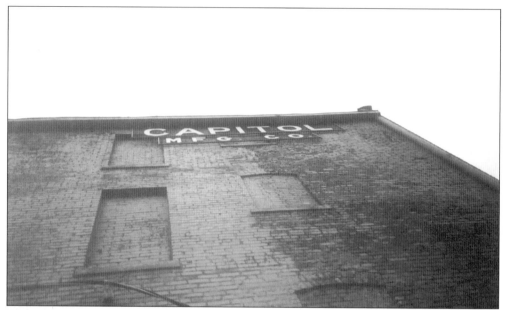

The 1980s saw the Brewery District become a wasteland. The breweries were long gone, and the industrial firms began to vacate their factories and warehouses. One such firm was Capitol Manufacturing, a thriving company with plants in Westerville and West Jefferson. They closed their main Columbus plant gradually between 1970 and 1993, when the building was finally shuttered.

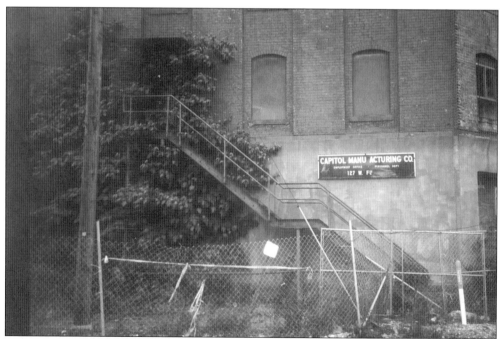

These photos were taken of the abandoned Capitol Manufacturing building in April of 2001. By this time the Brewery District had been the subject of a massive urban renewal program, and Capitol was the last remaining original building which hadn't been demolished or remodeled. This shows the catwalk at one end of the sealed and fenced-in building.

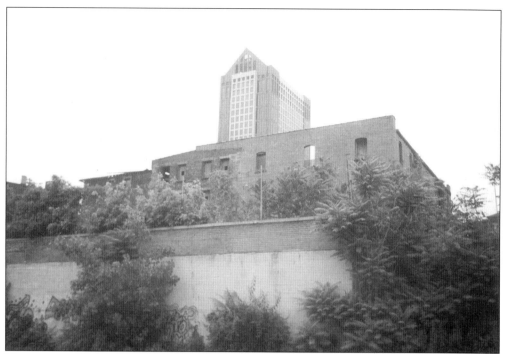

This picture shows Capitol's position in relationship to downtown Columbus. There were originally thirteen buildings in the Capitol Manufacturing complex, but by this time all but three had fallen to the wrecking ball. The rearmost building was mainly a shell, without a ceiling or complete floors at any level. Just feet away from the Capitol buildings, the Brewery District had become a popular nightlife destination and the location of the headquarters of CD101 FM radio.

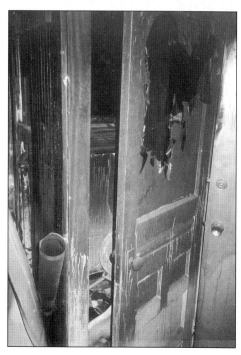

With the renewal of the Brewery District, plans were underway for the old Capitol property. Some favored demolition, while others proposed turning it into an apartment complex. Pictured here is a door in the main building of the Capitol complex, third floor. Severe fire damage had affected the upper levels of this building, which had not seen use since 1978.

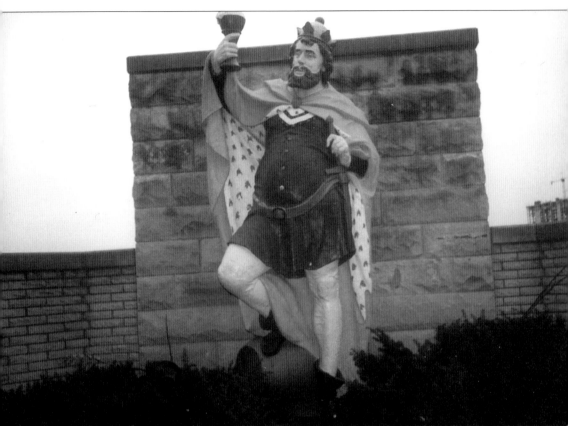

King Gambrinus, the mythological inventor of beer, has reigned over the Brewery District since 1905, when he was made to grace a pedestal high on the wall of the August Wagner Brewing Company. He came down in 1975, when the August Wagner building was demolished and was mounted in a pocket park at Front and Sycamore Streets, shown above. In 2000, with the restoration of much of the old Brewery District, the King was moved several feet up Front and stationed at the doors of a new office building.

Four

FORT HAYES

The main gate at Fort Hayes is guarded by soldiers in this photo—a sight not seen since the 1970s. Fort Hayes has certainly seen better days. Today its Cleveland Avenue grounds are known for the Columbus Public Schools bus depot and alternative high school there, as well as the dozen or so abandoned military buildings. But at one time Fort Hayes was a major military base with a history stretching back to the Civil War. The land where Port Columbus International Airport now stands was once the artillery range, and base housing was set up as far out as Hamilton Road.

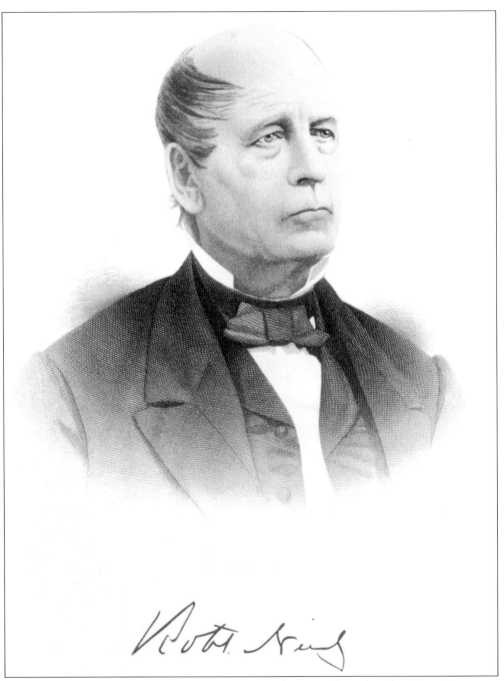

Robert A. Neil and his brother William earned a small fortune from the Ohio Stage Company, which they founded in 1828. With this money the Neil family became prominent landowners around Columbus. They eventually sold the land to the state of Ohio for the construction of the college which would become Ohio State, and sold the land to the federal government for the construction of a United States Barracks northeast of the city. The sale was finalized on February 17, 1863. The base would be known as the United States or Columbus Barracks until 1922, when it was renamed in honor of former Governor and President Rutherford B. Hayes.

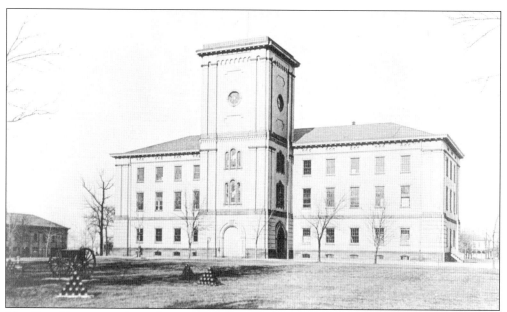

The Shot Tower is perhaps the most recognizable building in the Fort Hayes complex. Before 1900 this building, which stands at the center of the main field, was known as the Barracks or the Arsenal. It was used to house soldiers and store small arms, but its outward appearance, with the high tower, gave people the impression that shot would have been made there. The building could never actually have been used for such a purpose, because floors obstruct the drop from the top of the tower, where molten lead would be poured in a real shot tower, and the base, where it would land in water and cool.

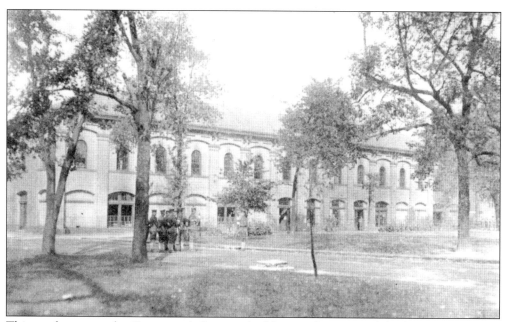

This was known as the Company A Quarters building, and was one of the largest buildings at the base. Aside from housing soldiers, the second floor eventually featured extensive recreational facilities, including a full-size basketball court and gymnasium.

New recruits and transfers got their first look at Fort Hayes by way of the Receiving Station, shown here. The building was positioned near the gates so each visitor could be checked in and out at a time when Fort Hayes was considered a military installation of some importance.

A street and sidewalk in front of base housing is shown here, c. 1910. Before transportation to downtown Columbus became easily accessible, it was necessary for the base to function as an independent community, and in many ways it resembled a small town.

Soldiers took their meals at this mess hall. This building had many functions over the years, once serving as a headquarters for the 12th Company, and is one of the very few still in use today—as administrative offices for the Columbus Public Schools.

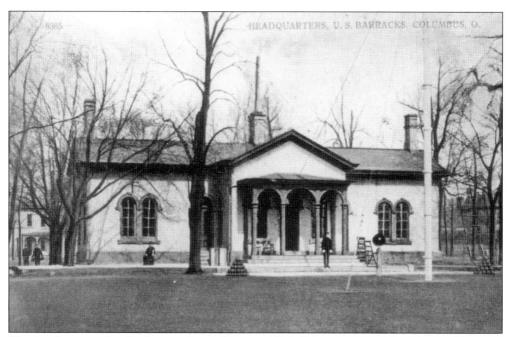

The headquarters for the base is shown here, c. 1900. Bureaucratic work and record keeping were done here. Prior to 1894, the building had been the mess hall, but when the new mess hall opened it was used for administration.

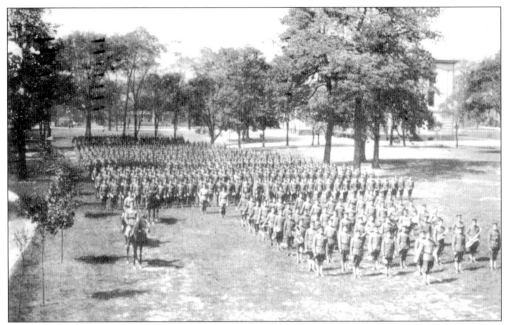

A demonstration of American military might is shown in this photograph, which was taken at Fort Hayes in 1917. Companies passing in review on the Fort Hayes grounds were a common sight during World War I, when the base's capacity was stretched by reserves training. Note the mounted commanding officer.

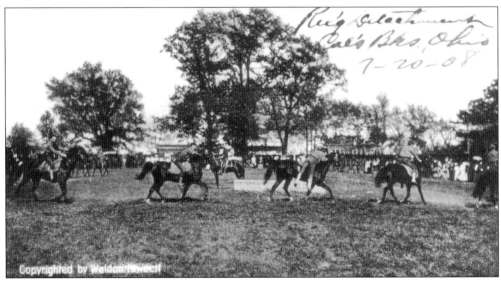

Mounted cavalry were still in use when this photograph was taken in 1908. World War I would make them obsolete in combat, but they were still used in parades and in demonstration. Fort Hayes featured a large stable up until the 1920s.

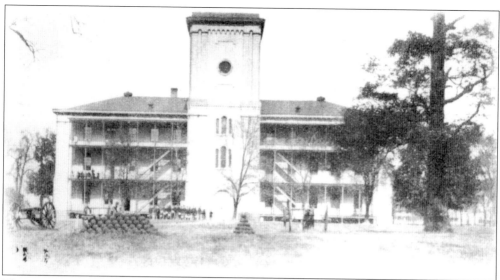

The Arsenal, or Shot Tower, prepares for operations. The men are standing ready in front of the building with the cannon set up nearby. The balconies on the Shot Tower were removed as part of the renovation, which turned it into the present-day home of the arts-focused alternative high school at Fort Hayes.

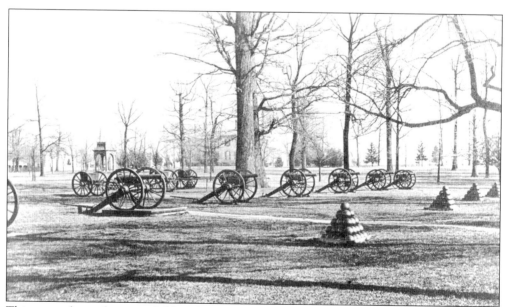

This scene shows the main field at the Columbus Barracks in 1889, with cannons lined up in staggered formation and cannon balls stacked in pyramids, ready for firing practice. Arrangements like this were more about show than actual combat practice, although many men trained at Fort Hayes would later fight in foreign wars.

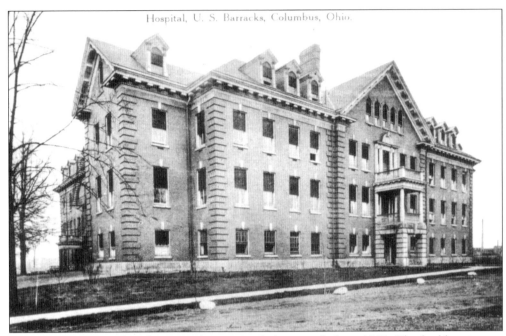

Hospital, U. S. Barracks, Columbus, Ohio.

The Barracks Hospital is shown in this postcard photograph from 1900. The building is now gone, but at one time it was considered one of the best hospitals in town.

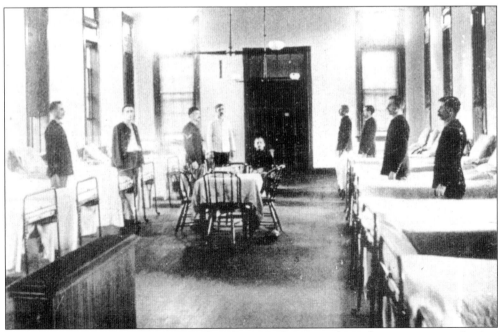

The sick and injured soldiers in a ward at the Barracks Hospital stand at attention at the feet of their hospital beds. They were not required to do so, but were probably posing for the camera. One soldier can be seen sitting at the recreation table at the center of the ward.

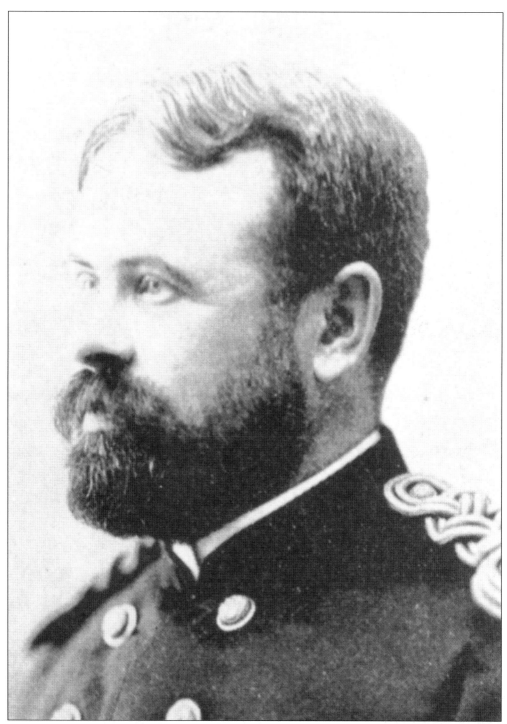

Captain James E. Pilcher is pictured here in 1896. Pilcher came to the Columbus Barracks in 1895 as a base physician and went on to become a professor of medicine at the Ohio Medical University and Starling Medical College. In 1905, he produced a major reference volume titled *Surgeon Generals of the Army*, which is still used and cited today.

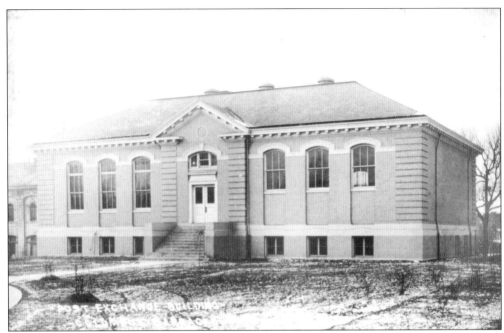

The Fort Hayes Post Exchange building was a much-anticipated addition. The construction project cost $25,000 and was completed in February 1909.

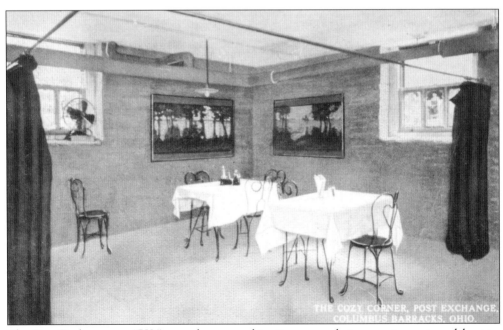

The Post Exchange, or "PX," served as a combination general store, restaurant, and lounge. Pictured here is the "Cozy Corner," a sort of dine-in eatery with privacy provided by black curtains hung on lines.

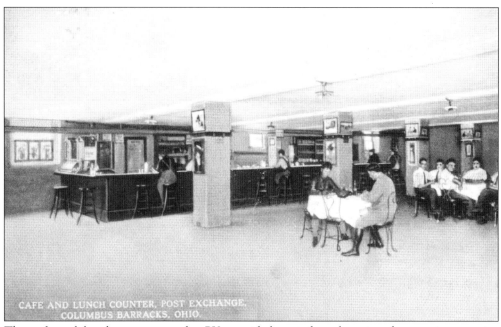

The cafe and lunch counter at the PX provided an informal setting for recruits to enjoy recreational time, as well as relieving them of the burden of mess hall food.

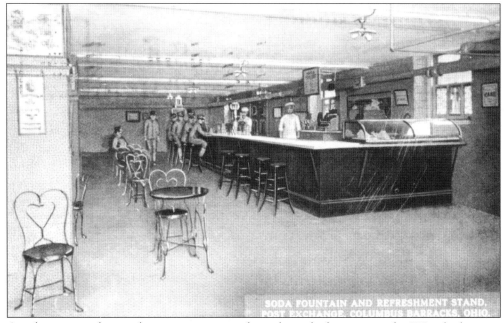

Another respite from military rations came from the soda fountain at the PX, which was a popular dating spot.

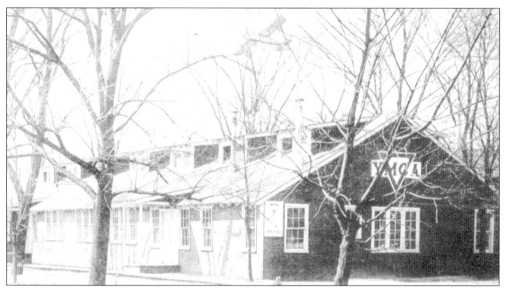

The base YMCA building appears here in the winter of 1918. Since exercise facilities were readily available on base, the Fort Hayes Y focused more on organizing non-military functions for the recruits, including parties and dances.

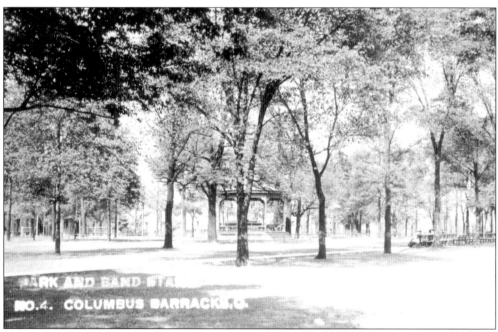

The park and bandstand were available to the soldiers at Fort Hayes; in the summer they were used for concerts and other outdoor events. The bandstand itself was later moved to Whetstone Park and rededicated on July 1, 1975.

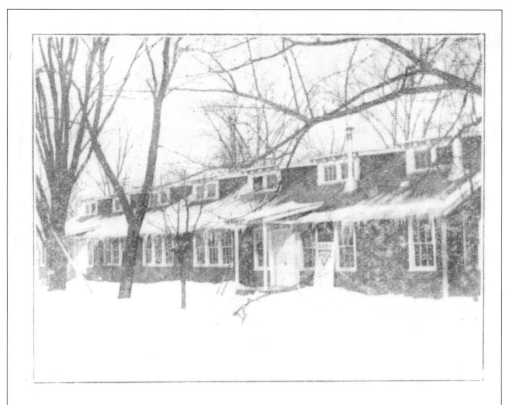

 Christmas 1918

Greetings and Best Wishes

from the Staff of the

Army Y. M. C. A.

Columbus Barracks, Ohio

Christmas cards like this one were distributed each Christmas by the base YMCA to recruits, many of whom were unable to be home for the holidays.

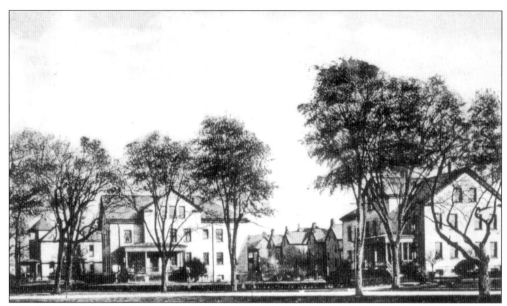

This photo and the next show the Officers' Quarters at Fort Hayes. Commissioned officers with families were offered spacious houses split into apartments for their living quarters. This was a far cry from the dormitory-style living enjoyed (or endured) by ordinary soldiers.

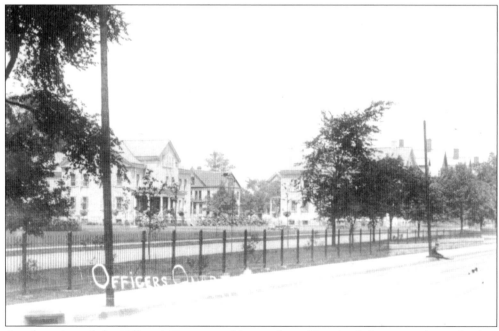

Another view of the Officers' Quarters—this one from Cleveland Avenue—shows the low fence and yards which surrounded the houses, giving them a homey, neighborhood look. In 2000, only one of the Officers' Quarters buildings still stood.

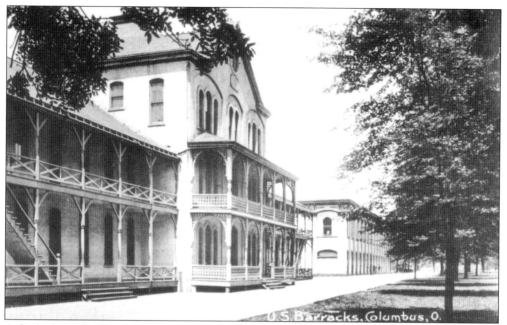

A look down Buckingham, the main drag inside the confines of the base, shows both the Company C and Company A Quarters buildings in their heyday, *c.* 1900. In 2000, both of these buildings were still standing.

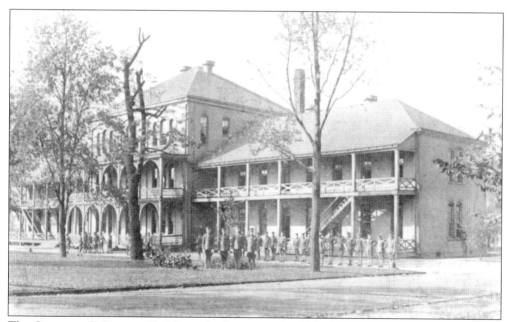

The Company C Quarters Building, also known as the 12th Company Headquarters, is shown here in 1898, with troops from the 12th Company lined up out front.

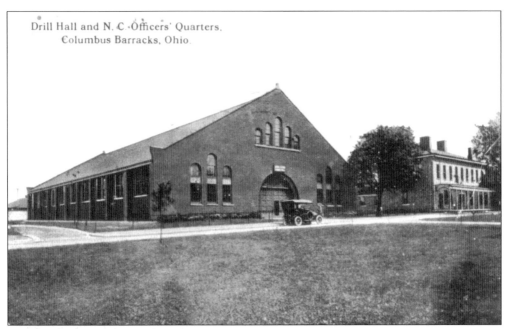

Drill Hall and N. C. Officers' Quarters.
Columbus Barracks, Ohio.

This postcard shows the Drill Hall at Fort Hayes, which was also home to the Non-Commissioned Officers' Quarters when it was built in 1910. The enormous, cavernous building housed drill assemblies, indoor exercises, and, in later years, the motor pool.

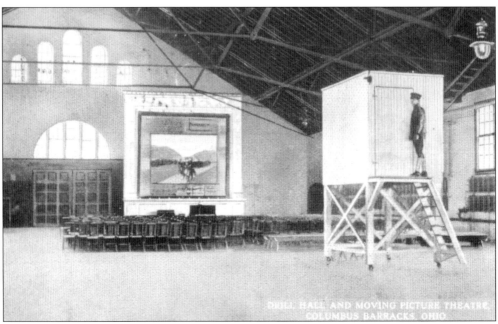

A soldier stands at the door to the projectionist's tower while he prepares a movie in the Drill Hall. A portable screen, projection booth, and chairs were sometimes set up in this building for base film screenings. In this picture the chairs haven't been arranged yet; the movies were shown after dark.

This is the Drill Hall as it appears today (June 2000). Most recently occupied by a metal shop, it stands vacant off of Cleveland Avenue. Old munitions dumpsters surround the building, which is said to be the home of a ghostly soldier who died mysteriously in jail after he was brought up on charges for falling asleep on duty. The rusted sign on the fence reads: "No Civilian Vehicles Beyond this Point."

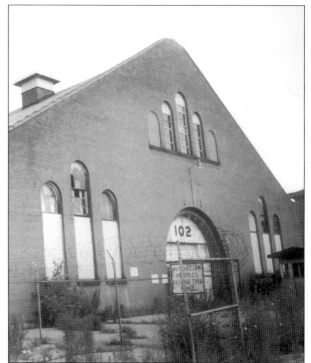

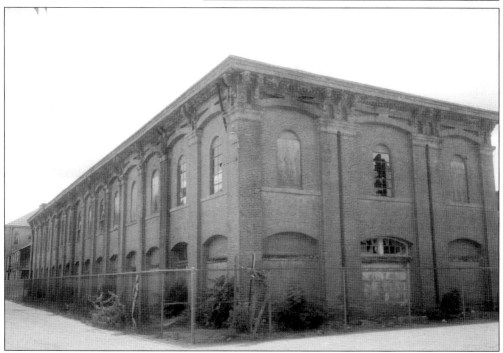

The Company A Quarters building is in a condition as sad as the Drill Hall in this 2000 photograph. Many of the floorboards on the first level are missing, while others have warped into an uneven funhouse floor. The second-floor basketball court is still recognizable, although many of the windows are shattered.

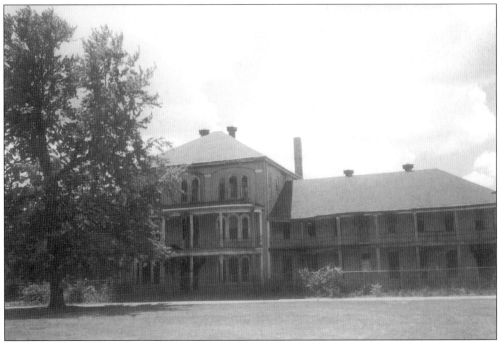

This photo shows the June 2000 condition of the Company C Quarters building at Fort Hayes. The balconies are still intact, but the building—like so many of its neighbors—is crumbling.

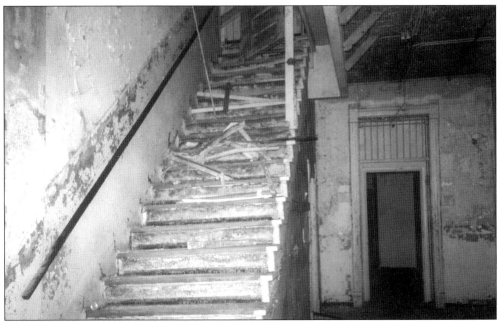

One of the dual interior staircases in the Company C Quarters building, shown here in June 2000. The railing is gone and debris has cluttered the stairs. Most of the rooms in this building were most recently used as classrooms, and are decorated with ruined chalkboards and tattered maps. People regularly explore the abandoned buildings at Fort Hayes, and as a result most have been severely damaged by vandals.

A fairly dangerous photograph here, taken from the second floor balcony of the Company C building. The balcony is missing floorboards and sags precariously, while the rooms it opens into have been heavily covered in graffiti.

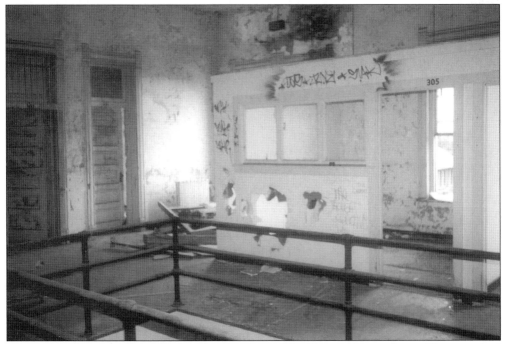

The thoroughly trashed top floor of the Company C building is shown above. The room had been turned into offices, the walls of which have been nearly torn down. Every window on this level is broken, and loose brickwork creates a hazard at the back of the building.

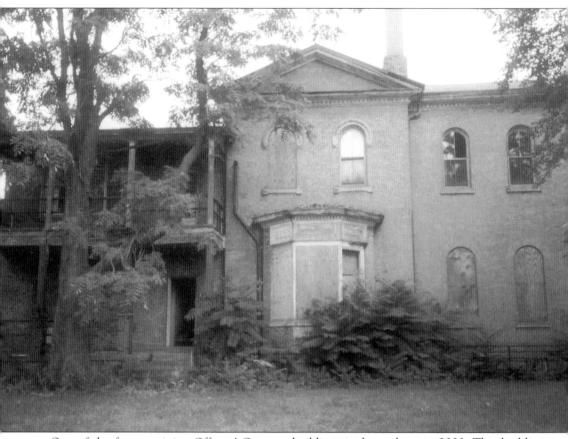

One of the few remaining Officers' Quarters buildings is shown here in 2000. This building fronts Cleveland Avenue and contains four separate two-bedroom apartments. Since it has been left abandoned the homeless have begun to reside there; at the time this photo was taken several rooms contained sleeping bags and clothing, and empty whiskey bottles littered the balcony.

Five
FRANK PACKARD'S COLUMBUS

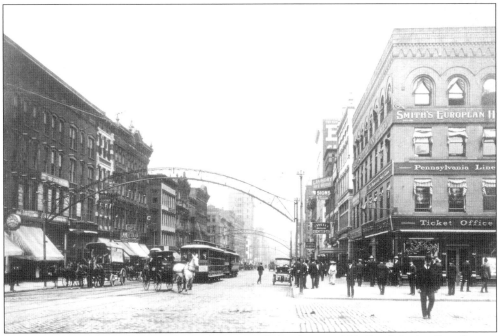

This look up North High Street shows downtown Columbus in 1908. Frank Packard's influence is visible in the presence of the Atlas Building, built in 1905. By the time of his death in 1923, Packard had transformed the face of Columbus, having designed more than a hundred buildings around the city. At the time of his death he was involved in an ambitious design project for the downtown area, intended to better incorporate the riverfront. Evidence of this plan can be seen in the placement of buildings such as City Hall, the old Central Police Station, and Central High School.

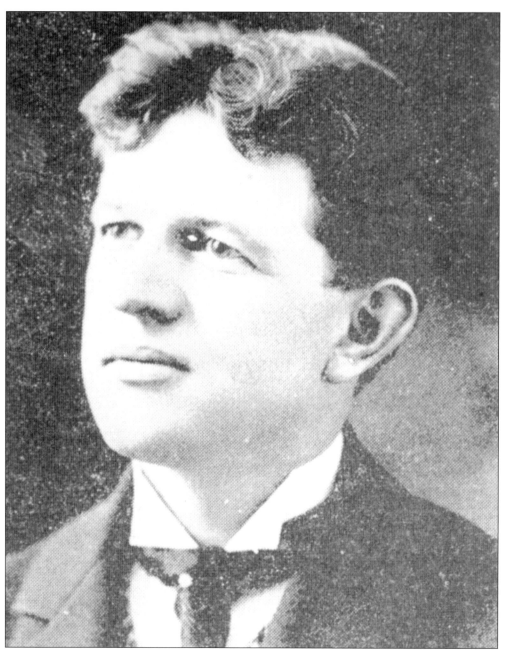

Frank Lucius Packard was called "America's foremost institutional architect," and he deserved the title. From his offices in Columbus he designed more than three thousand buildings in a variety of styles, many of which can still be seen all over the city. Packard's designs were never ostentatious; he had a reputation for respecting function while also finding room for some magnificent forms. Born in 1866, in Delaware, Ohio, his first job was as a chain carrier for the Delaware County surveyor. Later he found employment as an office boy for a Delaware architect. After taking classes at Ohio State, he headed off to the Massachusetts Institute of Technology, from which he received his degree in 1887. He went on to change the way conventional building design was viewed in America.

Like other important Columbus figures of the time, Frank Packard was honored with a respectful cartoon drawing. Here he asks the sarcophagus of the President of the Egyptian National Society of Architects who drew the plans for the Pyramids, while hieroglyphics whisper about Packard in the background.

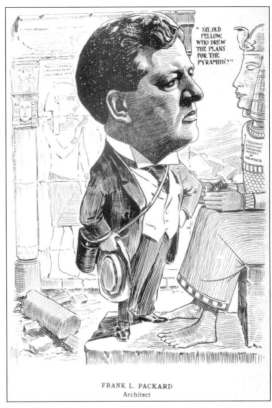

FRANK L. PACKARD
Architect

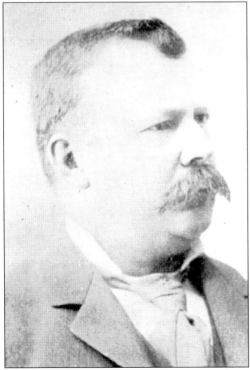

Joseph Warren Yost was nineteen years older than Frank Packard when they formed the firm of Yost and Packard in 1892. During his time in Columbus, J.W. Yost designed many of the surrounding county courthouses, as well as Orton Hall at Ohio State University. In 1901, he moved to New York and formed the firm of D'Oench and Yost, which lasted until 1918. He died in Avalon, Pennsylvania, in 1923—the same year as his young former partner.

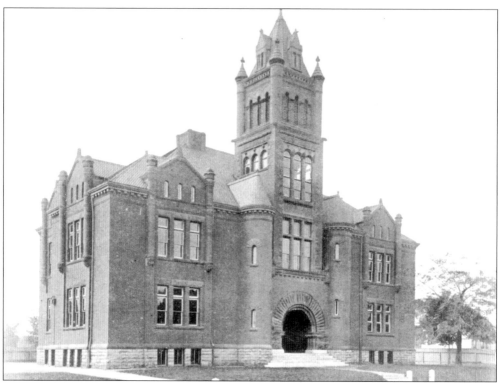

The Fair Avenue Public School was built in 1891, at 1395 Fair Street, for a cost of $32,692. Frank Packard was paid $672.00 for his design, which utilized themes he would return to on numerous occasions: high windows, peaked roofs, and arched doorways.

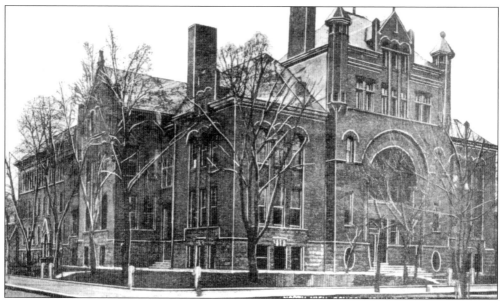

This, the original North High School, was designed by Frank Packard in 1898. The darkly gothic school building on West Fourth Avenue was renamed Everett Junior High School in 1925, when the new North High School opened for classes.

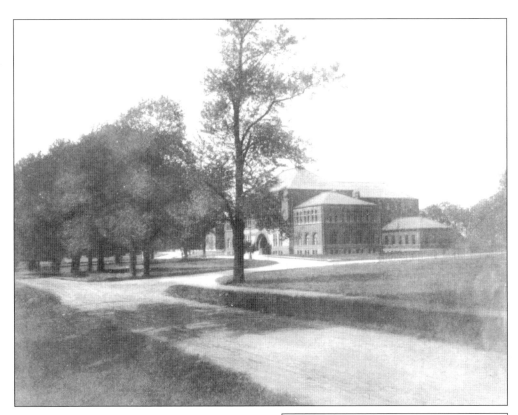

His partner, Mr. Yost, designed Orton Hall, but Packard caught up when the new Mines and Ceramics Building was completed in March 1906. It would be renamed Lord Hall in 1912, in honor of metallurgy professor Nathaniel Wright Lord. Packard's design for the building included an unusually flat roof and double exterior staircases leading up to a second floor main entrance.

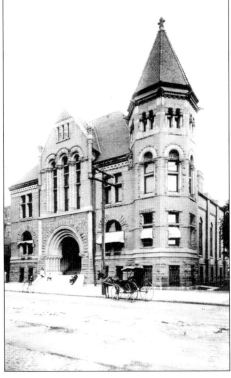

Yost and Packard were hired in 1892 to remodel this building—previously the Town Street Methodist Evangelical Church—into the Main Library of the Columbus Public Schools. The original building had been built in 1853; April 7, 1892, marked the reopening of the building as Yost and Packard's remodeled library.

One of the first jobs Yost and Packard took on was the design of the original YMCA at 34 South Third Street. The building went up in 1893, and stood for thirty years before being demolished to make way for the headquarters of the *Columbus Dispatch*.

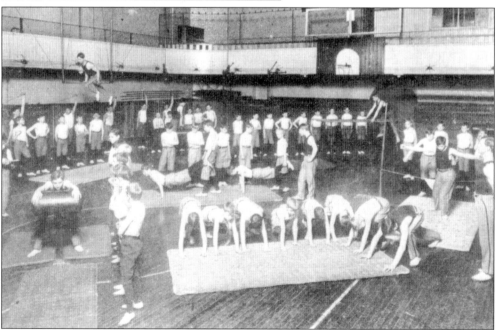

This photo shows the exercise room at Packard and Yost's YMCA on Third Street in 1908. When the first building was demolished, the Columbus YMCA moved to its new headquarters at 40 West Long Street.

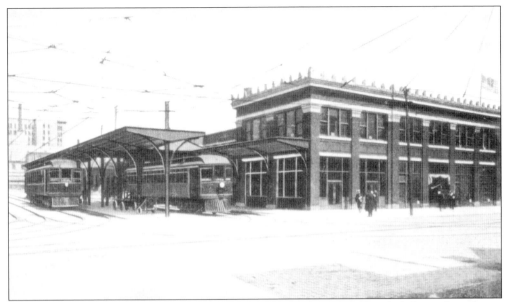

Packard designed this Interurban Terminal for the city in 1912. The slightly modern design differed from his previous work, involving rows of points along the roof, as well as the curved canopies for the train cars.

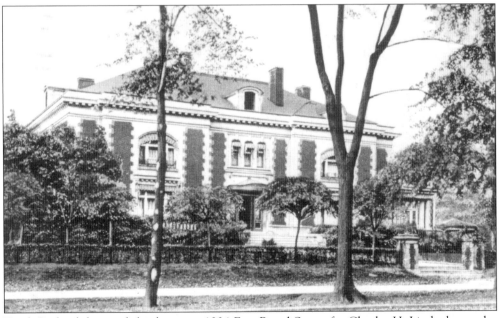

Frank Packard designed this house at 1234 East Broad Street for Charles H. Lindenberg, who resided there after construction was completed in 1904. It wasn't until 1919 that the state of Ohio purchased the mansion and began using it as the Governor's Mansion. For 38 years Ohio's governors resided there, beginning with James M. Cox and ending with C. William O'Neill in 1957. Today the house is preserved as a museum.

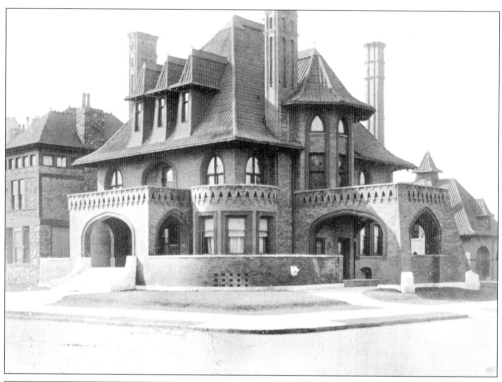

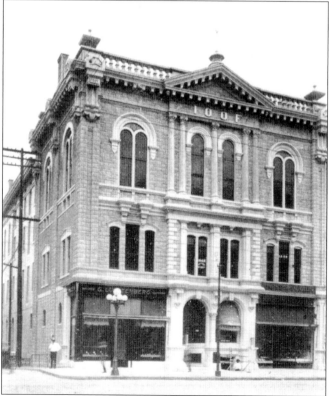

Frank Packard showed his range with the Peter Sells residence, shown here shortly after its construction in 1897. Peter Sells was the co-founder of the Sells Brothers Circus, and Packard was able to tailor the design to his tastes, giving the house a "big top" look with its quadruple chimneys and circular patterns.

The Odd Fellows Temple was a Frank Packard design in 1890, two years before he met Joseph W. Yost. The building would be the site of a tragic fire on February 19, 1936, in which five firefighters died.

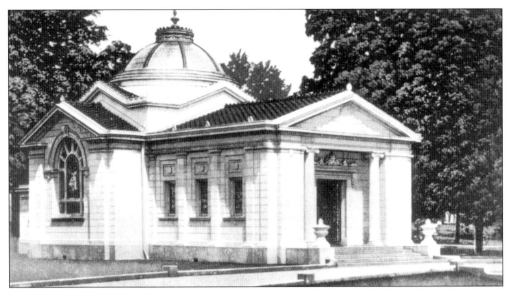

The main Chapel Building at Greenlawn Cemetery, 1000 Greenlawn Avenue, was a 1902 Frank Packard design. The somber, ceremonial exterior of the chapel is topped with an elaborate glass dome.

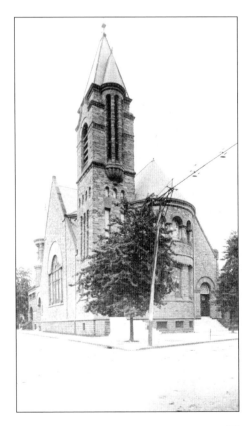

Another of Packard's religious buildings was the Presbyterian Church at 780 East Broad Street. The building was dedicated in 1894. Packard's tall windows fit well with the design of the tall stone church.

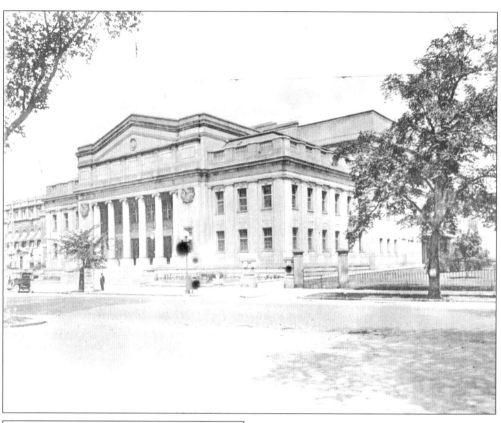

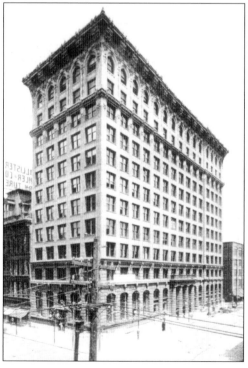

Perhaps the best-known Frank Packard building still standing is Franklin County Veteran's Memorial Hall. In 1903, the city of Columbus came to Packard with the contract for a new Memorial building to be placed at 280 East Broad Street. Packard's proposal was for a Romanesque building similar to the State Department buildings then going up in Washington D.C. In 1904, the cornerstone was laid, and two years later the building was dedicated. Weddings and performances were held here in the early days of the building. In 1964, Columbus's Center of Science and Industry (COSI) moved in. It stayed for more than thirty years, moving to new quarters at Central High School in 1999.

The Atlas Building, also known as the Ferris Building or the Capital Trust, is shown here in 1909. When it opened in 1905, it was one of the tallest buildings in Columbus: a 90,324 square foot, twelve-floor skyscraper. Frank Packard drew the plans for the building in 1903. It was the home of the Columbus Savings and Trust for several years.

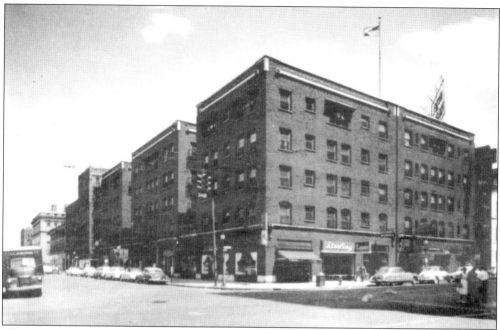

The Virginia Hotel began as the Virginia Apartments, a "Bachelor's Hall" on North Third Street. The forty-eight room building was built in 1908, on the site of the old Central Christian Church. Hurdenberg of New York was the original architect on the project.

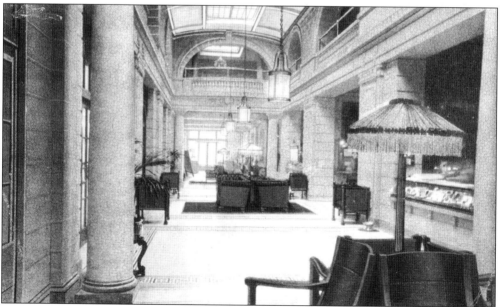

This photo shows the lobby of the Virginia after it was converted to a hotel. Frank Packard oversaw the renovation project in 1911; when work was completed he had made a first-class hotel out of an old apartment complex for single men. The Virginia was replaced in 1963 by the Sheraton Plaza, which later became the Adam's Mark Hotel.

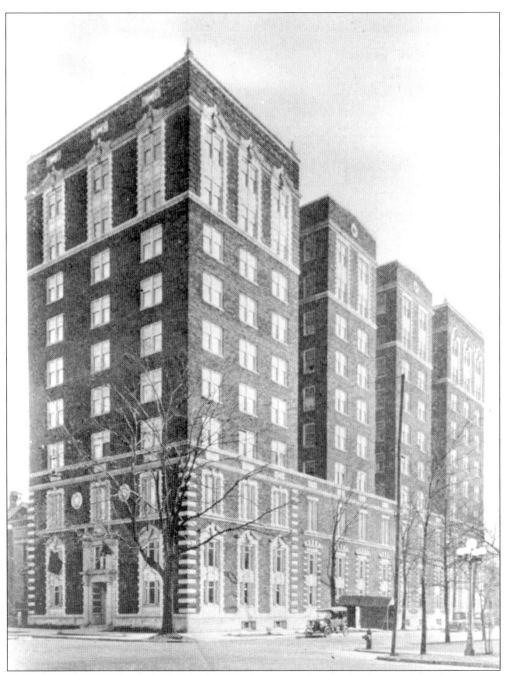

This photo features Frank Packard's famous downtown hotel, the Seneca. The Seneca was completed in 1917, and became an instant landmark—ten stories of red brick with white terra cotta and limestone trimmings which dominated the corner of East Broad and Grant. It was built with long-term residents in mind, largely consisting of apartments. As the Ohio State *Journal* noted in its September 16, 1917 edition, "Though the place is designed primarily for family occupancy, there will be some furnished rooms and suites for transients."

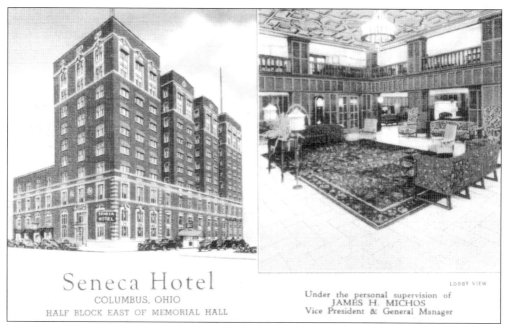

Seneca Hotel
COLUMBUS, OHIO
HALF BLOCK EAST OF MEMORIAL HALL

LOBBY VIEW

Under the personal supervision of
JAMES H. MICHOS
Vice President & General Manager

By the time the Seneca Hotel opened, Frank Packard had made a huge impact on downtown Columbus. East Broad Street was a good example; his buildings along it included Memorial Hall, the Presbyterian Church, the Ohio Governor's Mansion, and the Seneca. Two years later he would add the Edward Johnson house at 1349 East Broad to the list. Shown here is a double view of the Seneca, inside and out. One of Columbus's finest hotels, it featured 91 suites and a second-floor ballroom with a huge capacity.

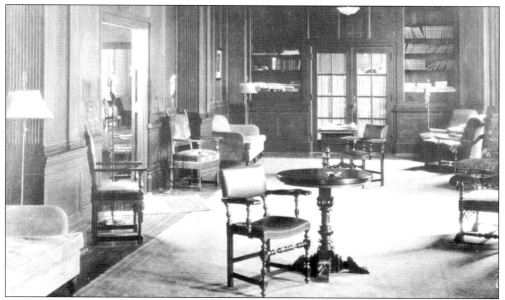

The Seneca Hotel lounge of the University Club is shown here in 1926. In its heyday, the Seneca provided offices for numerous clubs and organizations on the bottom floors, which had twice the floor space as the upper hotel floors. The first floor, beyond the spacious lobby, consisted almost entirely of furnished rooms like this one.

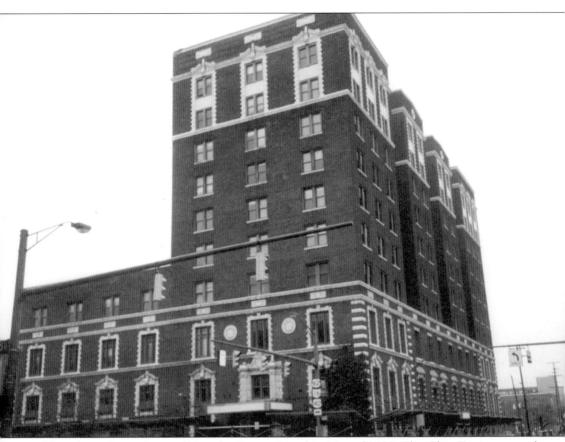

This photo shows the condition the Seneca Hotel in May of 2000. The Ohio Environmental Protection Agency had its offices in the Seneca from 1973 to 1989, but after the agency left the building stood completely vacant. The sidewalk outside had to be protected by a canopy due to the risk of falling chunks of limestone. In 1996, the city sued to have the Seneca designated a public nuisance, and plans were considered to demolish it for parking space. By 2000, many of the city's homeless had taken up occupancy in the neglected hotel.

Six

SCHOOLS AND COLLEGES

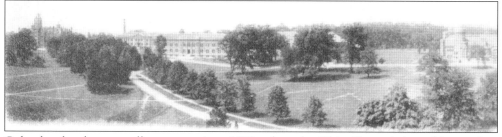

Columbus has been a college town since 1870, when the Ohio General Assembly voted to create the Ohio Agricultural and Mechanical College under the auspices of the Morrill Act—also known as the Land Grant Act. It would have remained the Agricultural and Mechanical College if it hadn't been for the efforts of Joseph Sullivant, a member of the first board of trustees who led a "broad gauge" faction which favored the inclusion of the liberal arts in the college's curriculum. By a single vote the college avoided becoming Ohio A&M, and classes began there on September 17, 1873. In 1878, the first class—consisting of six men—graduated, and the school's name changed to The Ohio State University (OSU). The panorama above shows OSU as it appeared shortly after the first graduation, from across the central green which would come to be known as the Oval. At the left is University Hall; the Armory is at far right.

The old Central High School at 303 East Broad Street is shown here in 1883. Central was the first school in Columbus built to serve high school students exclusively. Constructed in 1862, its name was changed to The High School of Commerce in 1911, and it was finally closed at the end of the school year in 1924, when the new Central High took its place. It was used by the city for office space for four more years, until its demolition in December 1928.

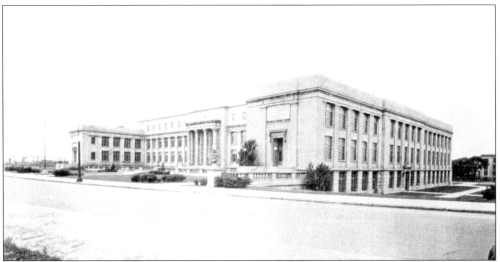

The new Central High School opened with the 1924-1925 school year and much fanfare. With its 18-acre campus and beautiful location on the west bank of the Scioto River, it was considered the pride of the Columbus Public Schools. For six decades it remained the definitive Columbus high school, highly visible from downtown and the Broad Street Bridge. By the 1980s, suburban high schools had taken over, and Central's Franklinton neighborhood had deteriorated considerably. The last students left the building on June 6, 1982, and the building remained largely unused until it was heavily remodeled in 1999, for use as the new home of Columbus's Center of Science and Industry (COSI).

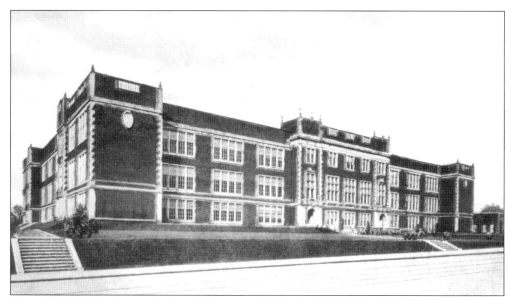

Central High School was the first of five major Columbus high schools built to serve students on each side of town. Shown here is the second North High School on Arcadia Avenue. The old North High occupied a distinctive structure at Dennison and Fourth, built in the Jacobethan Revival style. It opened in 1892, and operated until 1924, when it became Everett Junior High. The following year the new North High School was dedicated.

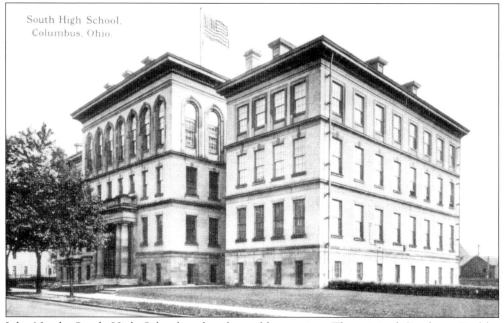

Like North, South High School replaced an older version. The original South on Deshler Avenue became Barrett Junior High, and the new one was built in 1924 on Ann Street. This postcard photo is of the original South, now Barrett, in German Village.

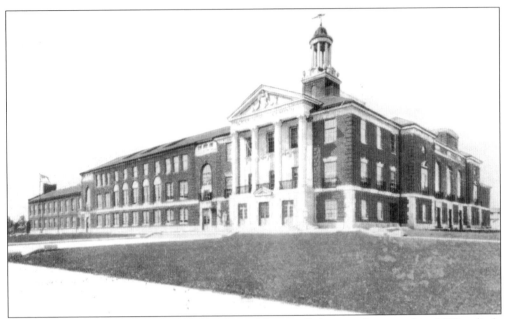

This is the "new" West High School at 179 South Powell Avenue. It opened in 1929, a little later than its north and south counterparts, replacing the old West High on South Central Avenue. Today the old West High is Starling Middle School.

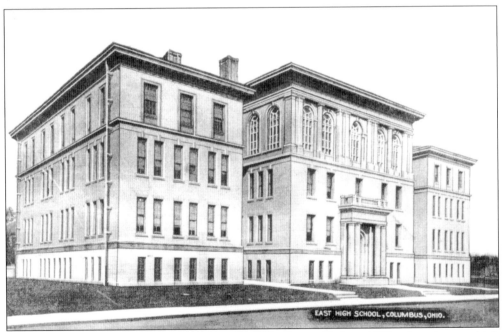

This, the original East High School, became Franklin Junior High in 1923, when the new high school was built on East Broad Street. The school is shown here in 1912, when its address was still 1390 Franklin; the street's name was later changed to Bryden Road.

The pride of Columbus schools and colleges in the early part of the twentieth century was James Grover Thurber, author, humorist, and political cartoonist for *The New Yorker*. Thurber grew up at 77 Jefferson Avenue in Columbus. He attended the Sullivant School and later graduated from East High School in 1913. Going on to Ohio State, he majored in Journalism, but dropped out to become a cryptographer in Paris. He later returned and was a statehouse reporter for the *Columbus Dispatch*. His books and stories include My *Life and Hard Times* and "The Secret Life of Walter Mitty," which was later made into a successful film starring Danny Kaye. Shortly before his death in 1961, he presided over the dedication of Denney Hall, Ohio State's new Department of English building. Today Thurber's house is a museum and cultural center, and his alma mater has honored him by naming one of the theaters in the Drake Student Union after him.

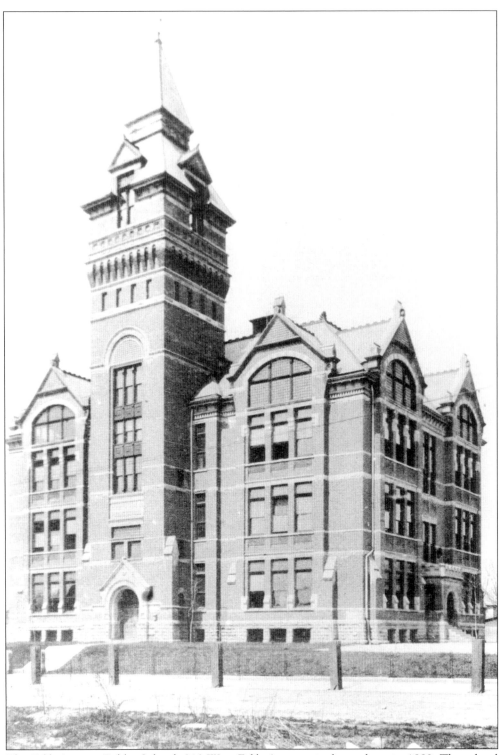

The Fifth Avenue Public School, 210 West Fifth Avenue, is shown here in 1889. The school was only three years old when this photograph was taken.

When Indianola Junior High School opened its doors to students on September 7, 1909, it did so as the first Junior High School in the United States. The building was later used as an elementary school.

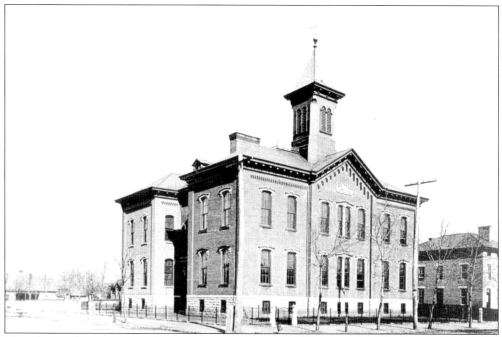

This photo of Franklinton Elementary School was taken in 1889. When excavation began in preparation for the school's construction twelve years before, artifacts were unearthed from the old Franklin County Courthouse, which had been built on the same spot in 1809. Both buildings shared the sinister address of 666 West Broad Street. The Franklinton School was razed in 1959, to make way for freeway construction.

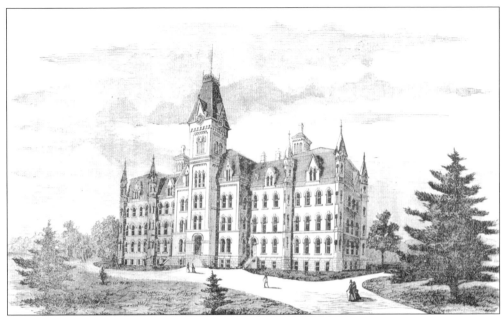

When the Ohio Agricultural and Mechanical College was first established, it was housed entirely within this building, which would later be known as University Hall. This engraving was made in 1873, the year the college opened its doors.

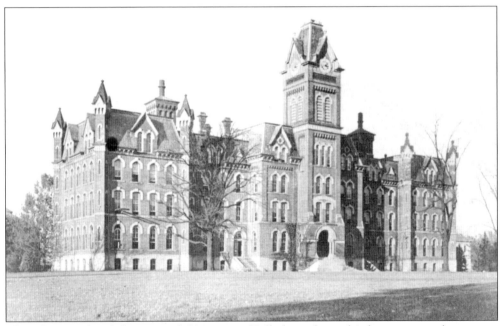

This photograph of the original University Hall dates from the late-nineteenth century. Although by this time other buildings, including Mechanical Hall, the Armory and Gymnasium, and the first Chemistry Building, had been built, University Hall still housed the main library and offices at OSU. By 1971, the structure was deteriorating badly and no longer met fire code requirements. It was demolished and replaced by a new University Hall, a building with all the major exterior features of its predecessor but a completely modern interior.

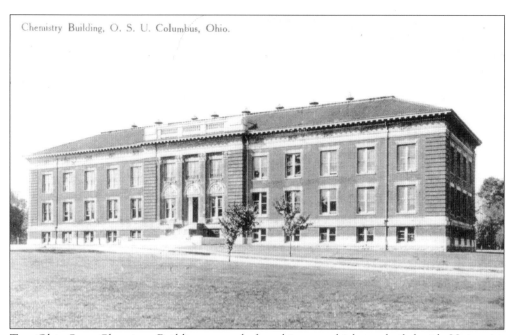

Chemistry Building, O. S. U. Columbus, Ohio.

Two Ohio State Chemistry Buildings came before this one, which was built beside University Hall in 1906. In 1929, it was renamed Derby Hall in honor of Professor Samuel C. Derby. Today it remains as one of the oldest buildings on campus.

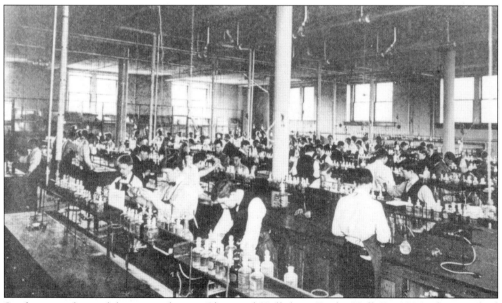

Students work in a laboratory class in Chemical Hall, later Derby Hall. By 1906, class size had grown large enough to require rooms and labs of this size for prerequisite courses.

The Botany and Zoology Building is shown here, *c.* 1920. The "B&Z" (as student handbooks called it) was built on Neil Avenue near Mirror Lake, and its large front steps were a popular place to study. Here you can see the greenhouse on the south end of the building, and farm fields stretching to the Olentangy River behind it.

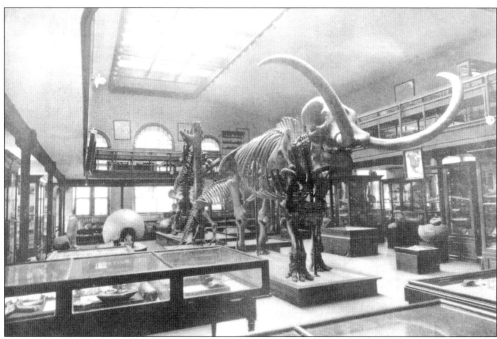

This photo shows the Orton Hall Zoological Museum, *c.* 1907. The mastodon skeleton in the middle of the room is the N.S. Conway Mastodon, the largest male mastodon ever unearthed. It was discovered in Clark County in 1894. In 1971, the N.S. Conway Mastodon was moved to its present home at the Ohio Historical Society Museum.

94

This was the Botanical Laboratory at OSU from 1884 through 1941, when the building was demolished. In addition to classrooms and labs the building boasted an attached greenhouse. The university employed a florist full-time to maintain the greenhouse.

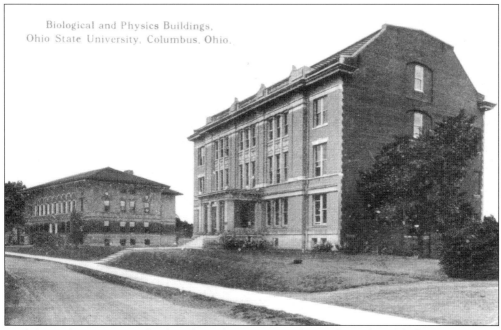

At left is Ohio State's Hall of Biological Sciences, and at right is the old Physics Building, c. 1915. Neither is still standing today.

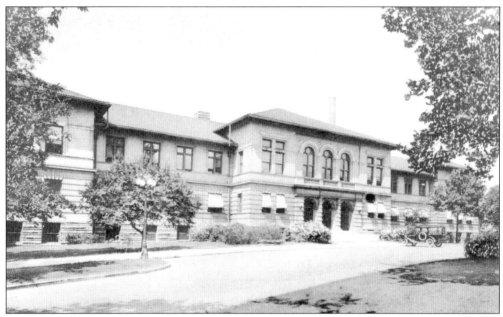

Townshend Hall was dedicated in 1898 as the first College of Agriculture building, and named in honor of Norton Strange Townshend, the first professor of agriculture at OSU. Today it houses the Department of Psychology.

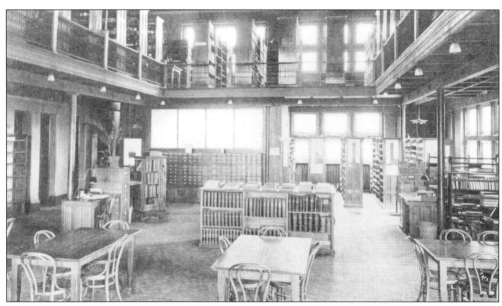

In this 1907 photograph we see the main reading room of the University Library. In 1913, it was replaced by the greatly expanded William Oxley Thompson Library, which opened at the head of the Oval.

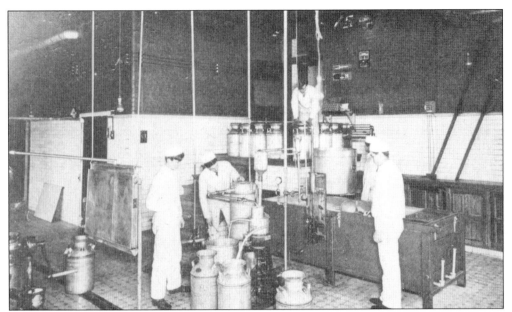

A laboratory class is conducted at the Ohio State University dairy farm. OSU's agriculture degree is one of the only programs which has been offered since the university first opened in 1873. Even when the city of Columbus turned campus-area land into high-value real estate, large portions on Kinnear Road were set aside as farm fields for educational purposes.

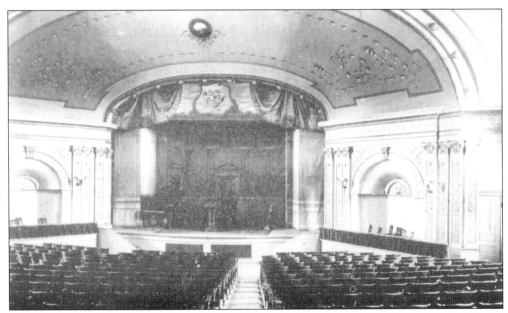

The University Chapel was with the University at the beginning, occupying a room in the old University Hall when it opened in 1873. The chapel room was later known as the Auditorium. The idea of a state university maintaining a chapel led to some sticky church-state separation issues in later years, but services were still being held when this photo was taken in 1907.

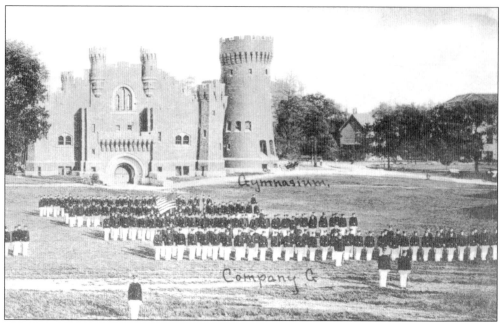

A cadet regiment—Company G—practices on the grounds of the old Armory and Gymnasium, which stood at 650 North Oval Drive. Designed by Frank Packard and built in 1898, the Armory burned in January of 1959. Today the Wexner Center occupies its spot.

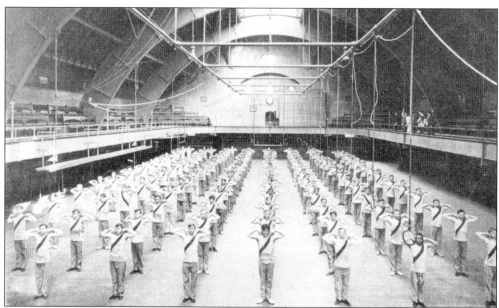

A class warms up in the main auditorium of the Armory and Gymnasium. The building was used for both ROTC military exercises and college physical education classes. When it burned, the area was cleared because of fears that munitions stored in the basement might explode.

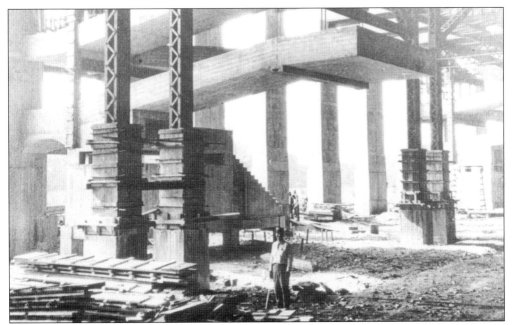

Construction workers make progress on the new Ohio Stadium on the western edge of campus. Ground was broken for the new stadium on August 3, 1921, in a ceremony involving University President William Oxley Thompson, Chief of Police Harry E. French, and Governor Harry L. Davis. In 1974, the Horseshoe would be added to the National Register of Historic Places. This photograph shows workers at a late stage in 1922 construction. The support pillars are being sheathed in concrete and the walk-up ramps have been given their finishing touches.

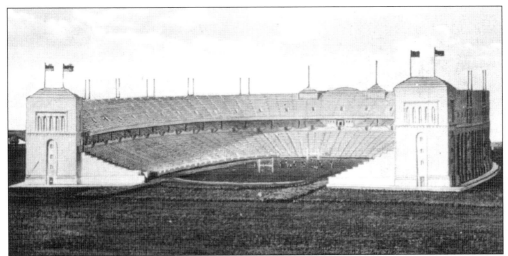

The finished horseshoe was dedicated October 21, 1922, with a capacity of 66,210—nearly a third of the population of the city of Columbus. All doubts were laid to rest on opening day, when the dedication game against Michigan drew an overflow crowd of more than 71,000. OSU football rarely failed to fill the seats in the ensuing years, and over time capacity was stretched by reorganization and the addition of bleachers at the open end of the Horseshoe. In 2001, a massive renovation project was completed, redesigning the outer shell of the stadium as well as lowering the field and increasing capacity to over 100,000.

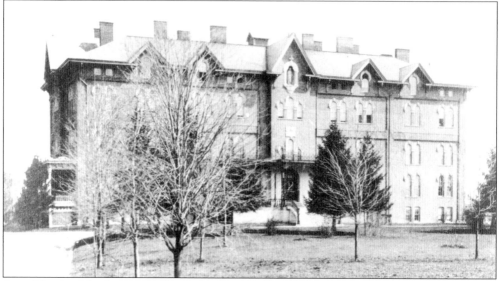

Saint Mary's of the Springs College began as an Academy for Girls established in September of 1868 by the The Dominican Sisters, an order of Catholic pioneer women who had initially settled in Somerset, Perry County. Their first academy was in Somerset, but they moved to Shepard, a small town on the fringes of Columbus, to serve a larger population. In 1910, Shepard was annexed by Columbus, and a year later the Sisters received a charter from the State of Ohio to begin offering college classes for women.

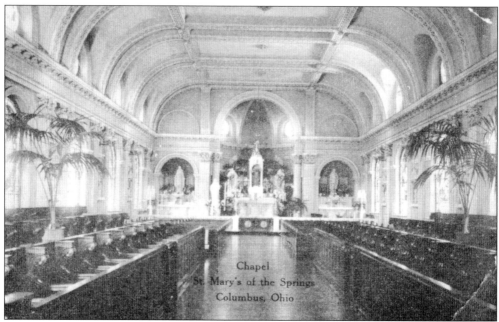

Saint Mary's of the Springs was formally established in 1924 as an inclusive Catholic college. Shown here is the college chapel as it appeared in 1907. Although they welcomed women of all faiths and ethnic backgrounds, they continued Catholic chapel services and conducted Mass. In 1964, their inclusive policy was expanded to include men, making Saint Mary's co-educational for the first time. Four years later, the college's name was changed to Ohio Dominican.

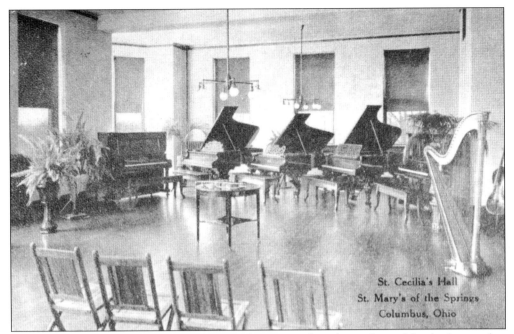

St. Cecilia's Hall
St. Mary's of the Springs
Columbus, Ohio

Music and education were the most popular areas of study at Saint Mary's. Its teacher certification program was approved by the state in 1929, the same year the first class graduated. Shown here is a music room at Saint Cecilia's Hall, replete with four pianos and a classical harp.

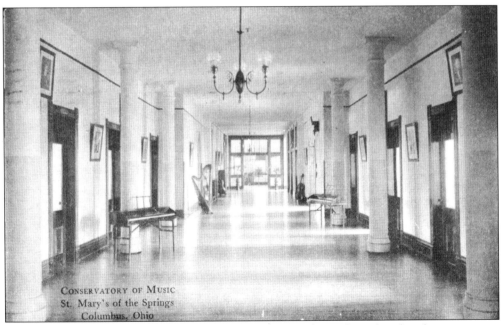

CONSERVATORY OF MUSIC
St. Mary's of the Springs
Columbus, Ohio

The hallway at the St. Mary's Conservatory of Music is shown here, lined with instruments. Choral music was a big part of the music curriculum, mainly because of its easy involvement in chapel services.

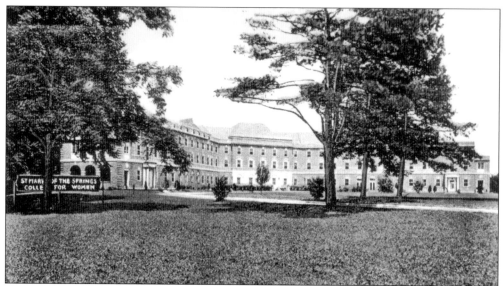

Sansbury Hall has been used for numerous things over the years—most recently a women's dormitory. It is said to be the home of Ohio Dominican's resident ghost, Mother Sans, a former Mother Superior who died when the old convent burned down. Today students say Mother Sans puts out candles and appears occasionally in the halls. The only time she ever got violent was during the first year the college went co-ed; for a while she slammed doors and windows but apparently got over it.

Otterbein College's Towers Hall is shown here in an 1873 illustration, shortly after its reconstruction following an 1870 fire. Otterbein University (as it was then called) was founded in Westerville in 1847. From the beginning, Otterbein accepted students regardless of gender or race—a policy which foreshadowed the role it would play in the Abolitionist movement. One of the most famous Otterbein alumni was Benjamin Hanby, who wrote a number of famous songs, including "Darling Nelly Gray" and "Up on the Housetop."

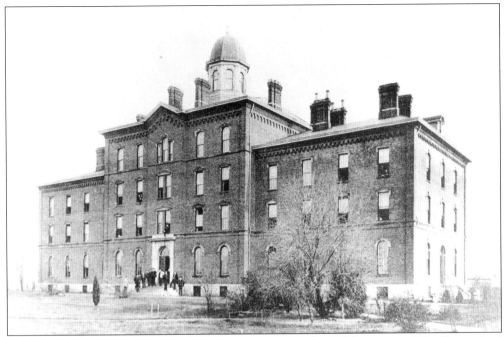

Capital University got its start in Canton, as The Theological Seminary of the Evangelical Lutheran Synod of Ohio. When it first moved to Columbus in 1832, it occupied log cabins on South High Street while construction on the new main building dragged on. It officially became Capital in 1850, when it moved to new quarters on East Town Street with a student body of 111.

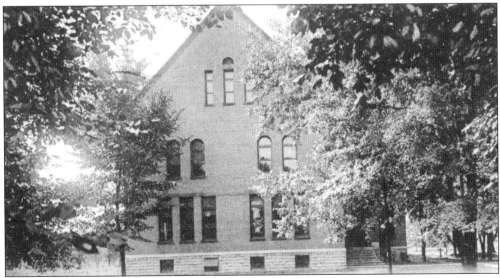

This building, Recitation Hall, is one of the bigger buildings on Capital's current campus on East Main Street in Bexley. It moved here in 1874, after spending nineteen years on North High Street at Goodale Avenue on land donated to the university by Ohio Attorney General Dr. Lincoln Goodale. Today Capital offers degrees in hundreds of fields; its music program in particular is nationally renowned.

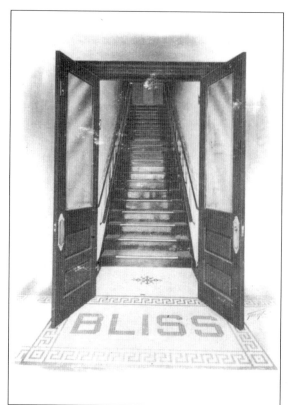

The doors are open in this postcard photograph of the entrance to Bliss College, which was located at 131 East State Street. Bliss closed its doors in October 1993, after an impressive 96 years in Columbus. It went bankrupt that year and was made ineligible for federal loans, and at the end of the summer term closed its doors for good.

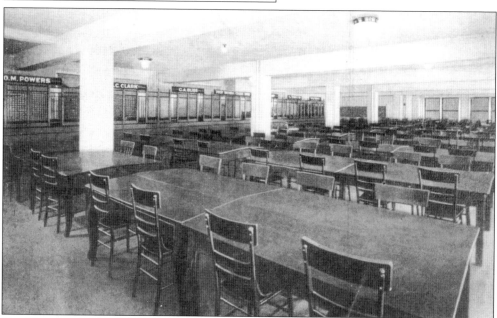

The Bliss College Advanced Actual Business Department is shown here in 1916. Bliss offered associate degrees in accounting and sales and marketing, as well as a bachelor's in marketing, court reporting, accounting, word processing, and medical assisting. It served mainly working students; the average age of a Bliss student was 28 when the college closed.

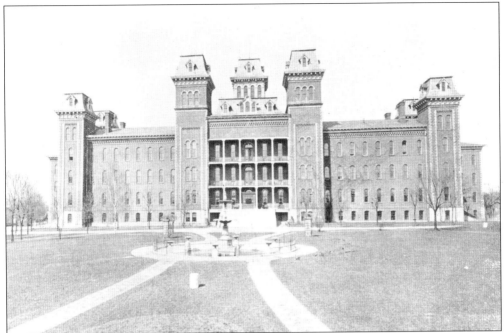

The deaf school at 450 East Town Street was one of the first institutions of its kind in the United States. The cornerstone was laid on October 21, 1864, and the building was completed four years later. It was designed by George W. Bellows Sr., father of the artist George Bellows. When the new deaf school was built at 500 Morse Road in 1953, the old building was used for office space. This photograph shows the school in 1889.

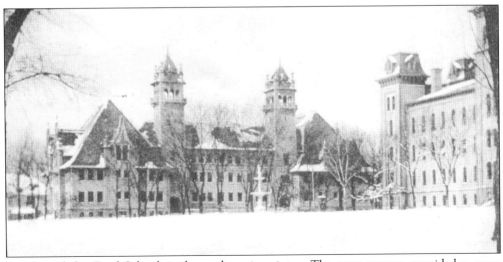

A wing of the Deaf School is shown here in winter. The new campus provided a more permanent home to an institution which had operated at rented quarters on North High Street since 1829. When the George Bellows building burned to the ground in 1981, only the side buildings were left standing. The Deaf School was known by many names during its nearly a century of operation, including Deaf and Dumb Asylum, State School for the Deaf, and Institution for the Education of the Deaf and Dumb.

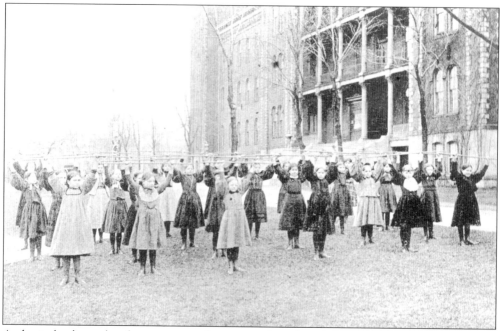

A physical culture class for younger students is conducted on the Deaf School lawn in this 1898 photograph. The institution provided an education for the hearing impaired at any age, but the bulk of their students were school age.

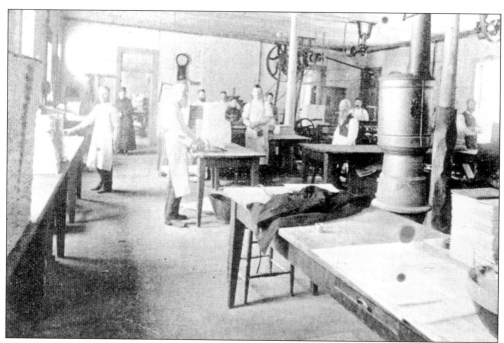

The deaf school bindery is shown here in 1898. Bookbinding was just one of the vocations available to deaf students. William Cawley, a student who attended the deaf school from 1877 to 1887, went on to become a well-known frontier scout in the Rocky Mountains.

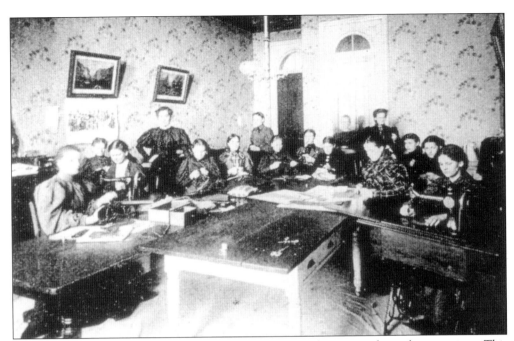

Women at the Columbus School for the Deaf were limited to non-industrial occupations. This photograph shows the sewing room in 1898. Other options open to female students included cooking and minor housekeeping.

This fountain was added to the Deaf School grounds in 1877. Even before the 1981 fire at the main building, the grounds were considered quite lush. After the debris was cleared in 1981, the land where the Deaf School building had once stood was replaced by a park, famous today for its topiary garden arranged in a representation of Georges Seurat's A Sunday on the Island of La Grande Jatte.

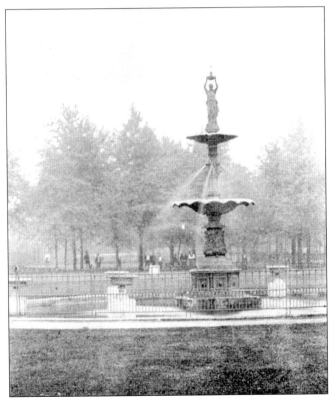

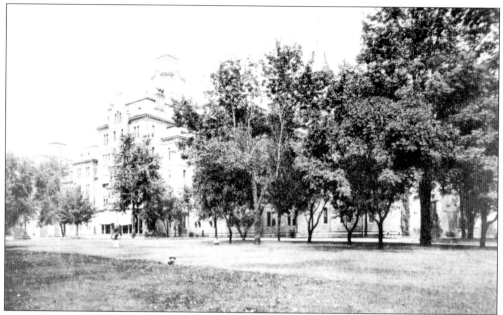

The second Ohio State School for the Blind is seen here in 1889. The first class at the old Blind School consisted of only six pupils, but the Civil War significantly increased the blind population in the United States, as well as the demand for institutions equipped to educate them. Columbus's Blind Asylum was one of the first of its kind. This, the second building to house the school, opened on May 21, 1874, with a class of about one hundred, replacing an older structure on East Main Street.

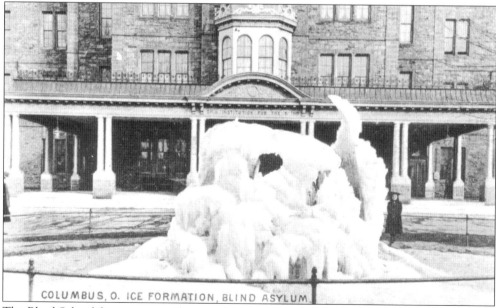

COLUMBUS, O. ICE FORMATION, BLIND ASYLUM

The Blind School fountain was a fixture of the imposing building's Parsons Avenue courtyard. In the winter it froze to a height of several feet. Over the years, the Blind School added numerous administration buildings to its grounds, and the fountain was eventually taken out to make room for a parking lot. This photograph dates from 1909.

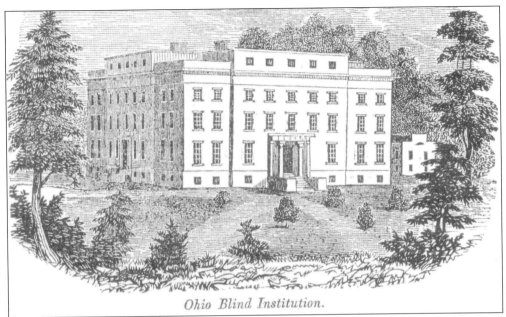

Ohio Blind Institution.

This 1847 engraving shows the original Ohio State School for the Blind, located on East Main Street. It opened in October of 1839, and quickly gained a reputation as an extremely progressive school, providing its pupils with training in an unheard of number of disciplines, including classical piano and, for the less artistically inclined, piano tuning. Previously many schools had trained the blind for little more than broom making, but the Columbus Blind School produced many successful alumni, including celebrated jazz musicians such as Teddy Robinson and Rahsaan Roland Kirk.

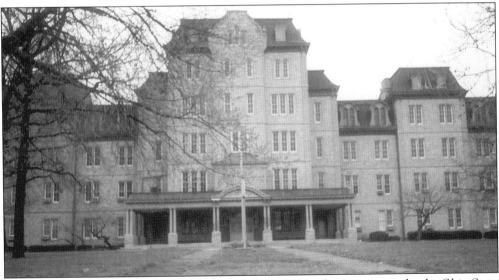

The Columbus School for the Blind is shown here in 2000, after its vacation by the Ohio State Highway Patrol and at the beginning of its renovation into the new Department of Health building. The six-story sandstone structure, an example of Second Roman-style architecture, had its spired towers removed before the Blind School departed for new quarters on North High Street. The lower tower rooms had remained untouched and unpainted since the late 1800s.

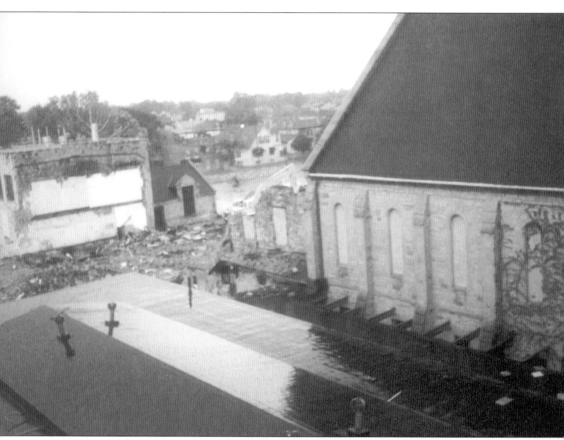

A shot through an upper room in the back of the Blind School shows the 2000 demolition of the rear wing. Only the four-story section of the main building would be spared the wrecking ball.

Seven

HOSPITALS AND
ASYLUMS

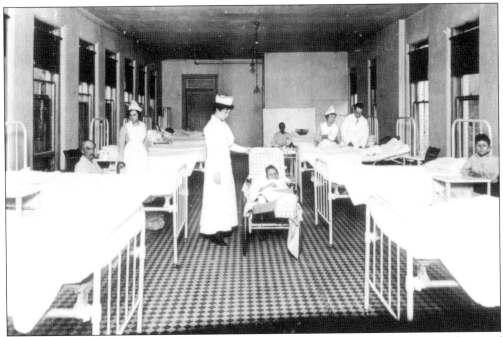

A children's ward at White Cross Hospital is pictured here. Columbus has boasted dozens of hospitals since Dr. Lincoln Goodale started the city's first private medical practice in 1832. Today Children's Hospital, east of downtown, is famous for its trauma unit, and the hospital complex of the Ohio State University is consistently ranked near the top nationally. Patients fly in from all over the eastern United States to receive treatment at the Arthur G. James Cancer Hospital. Mental health care has also come a long way since the days of the Lunatic Asylum on the Hilltop.

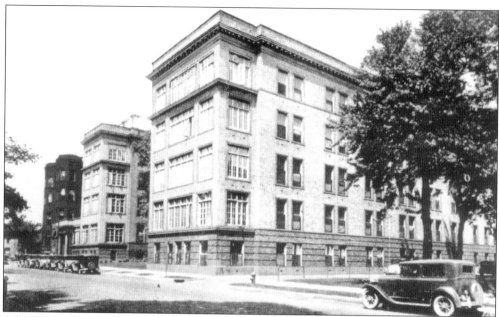

White Cross Hospital was originally known as the Protestant Hospital. It stood on Dennison Avenue until October of 1895, when it moved to the new building shown here at 700 North Park Street. The new White Cross was a major Columbus hospital during the first half of the twentieth century, with an idyllic location on Goodale Park with a view of the East Lake. It closed on April 10, 1961, and was replaced by Riverside Methodist Hospital on Olentangy River Road. The old White Cross building was demolished in 1970.

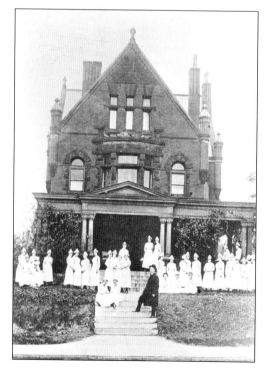

A nursing class poses for a picture in front of the White Cross Hospital Nurses' Home at 664 North Park Street. This building had a long history; it had originally been the home of early Columbus landowner William A. Neil, and later Ohio Governor William Dennison.

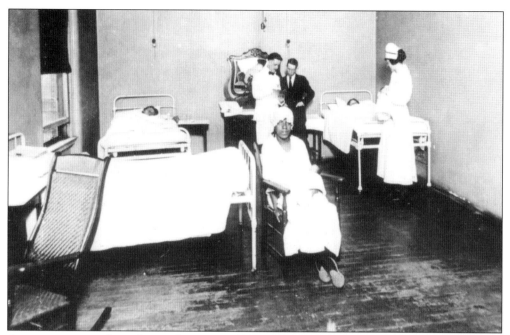

A maternity ward is shown here in 1920. Columbus's Protestant Hospital pioneered desegregation in its wards and practiced a non-discrimination policy in its hiring and education as far back as the turn of the century.

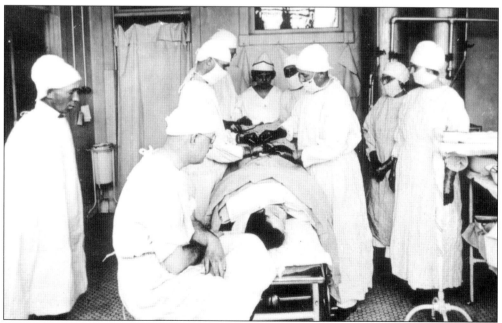

An operation is shown here being performed at the Protestant Hospital operating theater in 1920. Conditions might be considered less than sanitary by today's standards—especially the pulled-down masks of the surgeons. Further evidence of the hospital's progressive policies can be seen here: a black nurse is assisting in the procedure, and a black man, possibly a student, stands by at the left.

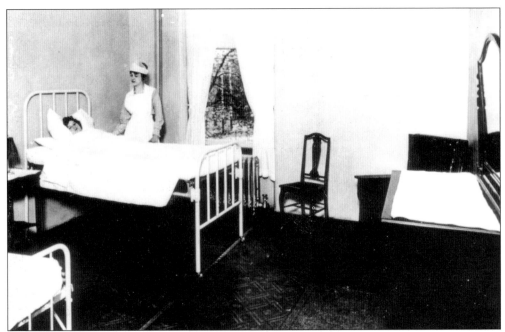

This 1920 photograph shows a patient being attended to by a nurse in one of the Protestant Hospital's patient rooms. Views of Goodale Park from the hospital rooms were thought to be therapeutic.

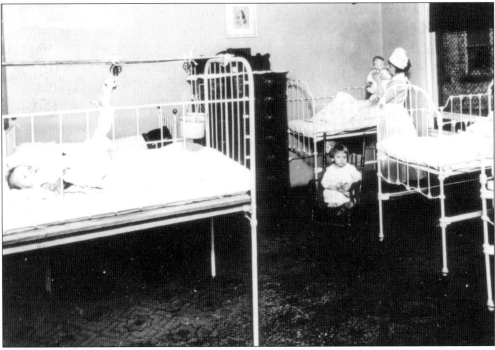

A pediatrics unit at the Protestant Hospital is shown here, also in 1920. A nurse holds a baby at the rear, while a toddler plays under one of the cribs. At the left a baby's legs are kept elevated by means of a pulley system with a bucket serving as a counterweight.

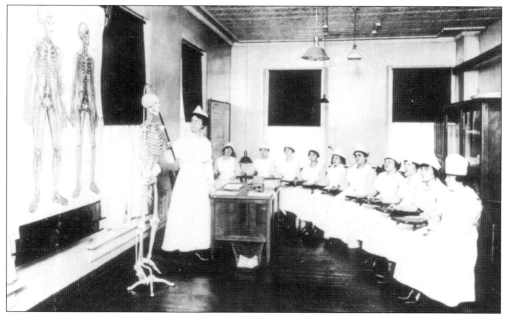

Nurses at the Protestant Hospital hear a lecture in a hospital classroom in this 1920 image. The nursing program had grown significantly since the first five graduates left the program in 1894; by this time classes were offered at the Children's Hospital, as well as the adjacent Ohio Medical University.

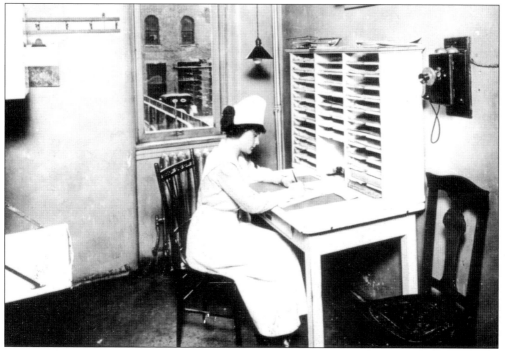

A nurse fills out forms in her station in this 1920 photograph. Nurses remained on call while doing paperwork; the lights high on the wall would alert her to any emergencies, as would the phone mounted above the desk.

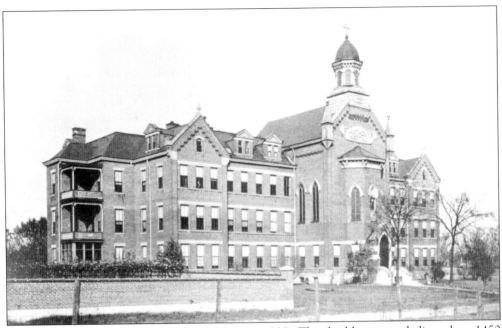

Saint Anthony's Hospital is pictured here, c. 1900. This building was dedicated at 1450 Hawthorne on November 11, 1891; its address was later changed to 1492 East Broad Street. Although a successful hospital, Saint Anthony's merged with Saint Francis Hospital in 1955, and was eventually demolished in 1970.

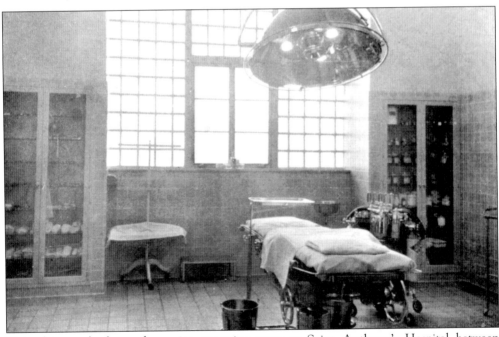

This photograph shows the major operating room at Saint Anthony's Hospital between operations. Like the OR at the Protestant Hospital on Park Street, the sanitary conditions would be considered sub-par today; especially questionable is the presence of an open window in the operating room.

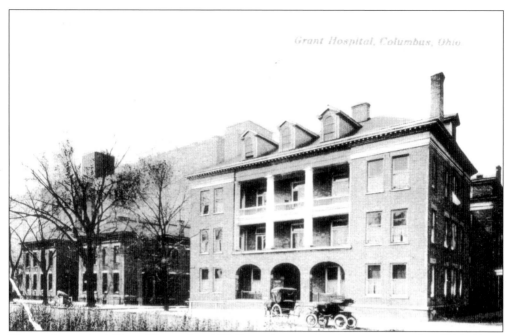

This is the original Grant Hospital at 125 Grant Avenue South as it appeared in 1910. Grant was founded in 1900 by James Fairchild Baldwin and was celebrated as an extremely modern hospital, complete with marble bathrooms and tubs on wheels which could be taken to patients' rooms to allow private bathing. Today the new Grant Medical Center stands just a block south of the old location.

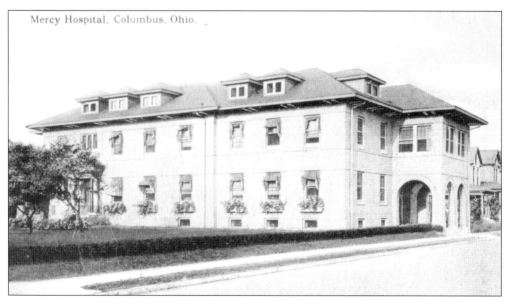

Mercy Hospital was organized on March 19, 1903, but remained homeless until this building was completed at 1400 South High Street in 1907. The address was later changed to 1430 and a new building was erected in 1973. In 1991, Mercy became the Columbus Community Hospital. Columbus Community operated for ten years, until it closed its doors to emergency services in early 2001.

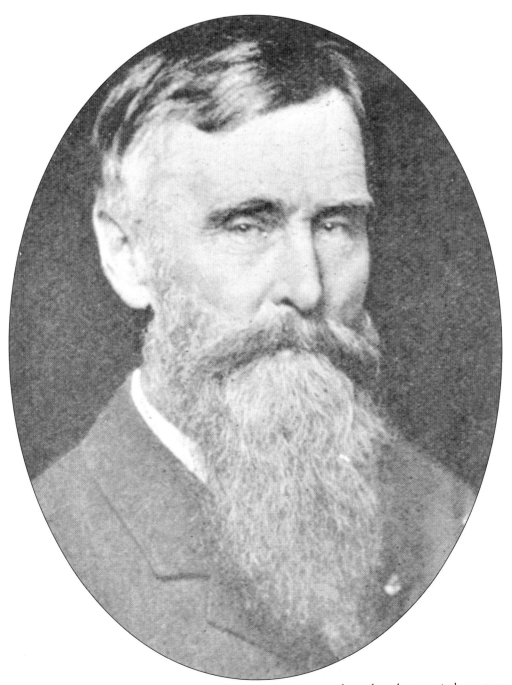

Dr. Starling Loving was an eminent physician in nineteenth and early-twentieth century Columbus. He helped establish the Saint Francis Hospital in 1865, and then went on to serve as trustee of the Starling Medical College, which would later become part of Ohio State University. After serving several years as a professor of materia medica, he was appointed dean in 1881. Dr. Loving died in 1911, but OSU honored his memory fifteen years later by naming the new medical building in his honor. Starling Loving Hall housed the first electrocardiograph machine in central Ohio.

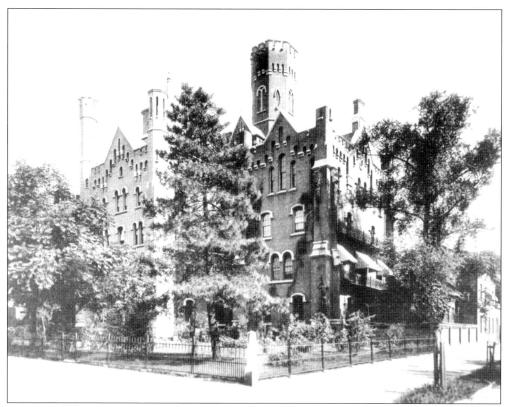

Starling Medical College and Saint Francis Hospital complex is shown here on East State Street, near the present-day location of Grant Medical Center. The building remained until 1961, when it was torn down to make way for the new Grant complex. The Ohio State University acquired Starling Medical College and incorporated it in 1914, moving it north to the area around Twelfth Avenue.

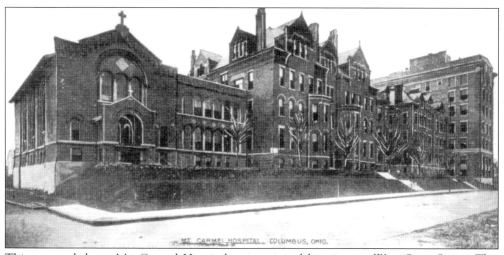

This postcard shows Mt. Carmel Hospital at its original location on West State Street. This gothic building was built in 1893. Today, Mt. Carmel occupies two state-of-the-art facilities and represents one of the oldest functioning hospitals in the city.

Not all Columbus hospitals were public. This 1919 photo shows the small hospital at the Jeffrey Manufacturing Company on East First Avenue.

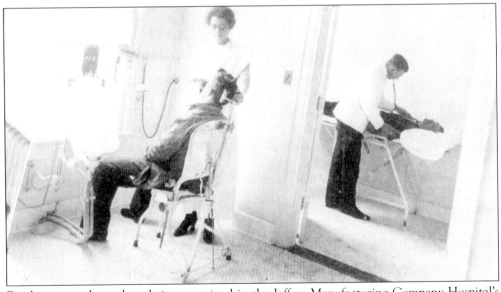

Employees are shown here being examined in the Jeffrey Manufacturing Company Hospital's private examination room. Jeffrey made mining implements in their factory near North Fourth Street, and provided medical care for employees injured while performing dangerous manufacturing jobs.

The Saint Clair Hospital is shown here in 1911, just one year after it opened its doors as a hospital on Saint Clair Avenue. In 1947, the hospital closed and it became the Saint Clair Hotel. When the hotel closed in 1976, plans were made to turn it into senior citizen housing.

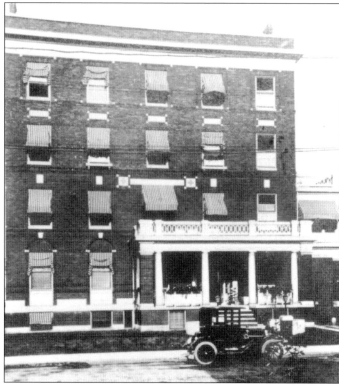

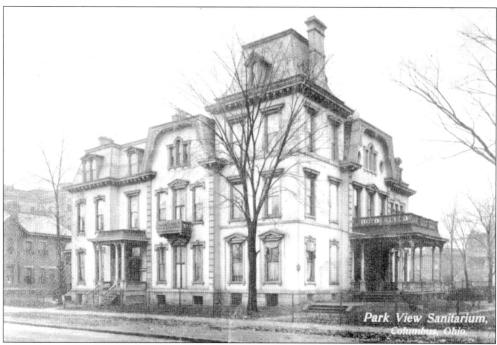

The Park View Sanitarium at 664 Park Street opened in 1921, and also served as nurses' housing for the nearby Protestant (later White Cross) Hospital between 1927 and 1930. It was originally known as the McKinley Hospital and was built in 1875.

This 1932 advertisement shows the Alcorn Eye, Ear, Nose, and Throat Hospital at 287 East Town Street. When Dr. John Alcorn opened it in 1907, it was the first hospital of its kind in Columbus. Dr. Alcorn was president of the Ohio State Medical Association in 1937. The Eye, Ear, Nose, and Throat Hospital operated until 1942.

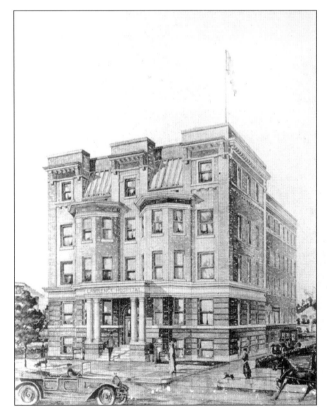

The Lawrence Hospital, illustrated here in 1915, was originally the residence of Charles H. Lindenberg at 432 East Town Street. It was expanded and heavily remodeled in 1900, and began functioning as a hospital. In 1921, it became the McKinley Hospital.

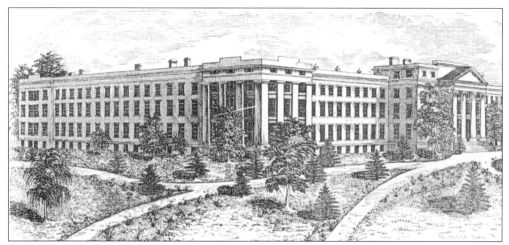

Construction on this, the first Central Ohio Asylum for Lunatics, was begun shortly after the Ohio Penitentiary was finished. It was completed on November 10, 1839, on West Broad Street. It burned to the ground on November 18, 1868.

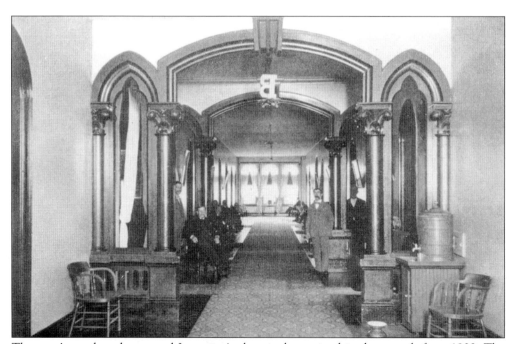

The men's ward at the second Lunatic Asylum is shown in this photograph from 1900. The well-dressed men in the picture are more likely hospital employees than patients, who were usually kept in prison-style uniforms.

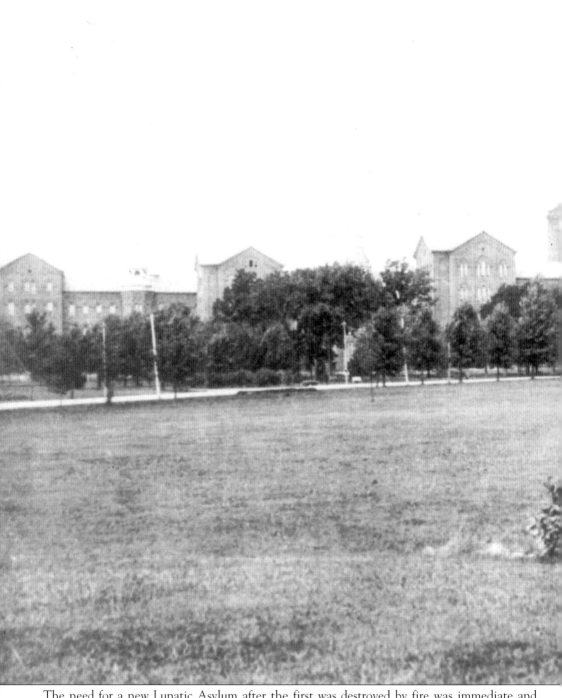

The need for a new Lunatic Asylum after the first was destroyed by fire was immediate and urgent. The city allotted a huge plot of land west of the city, in the Hilltop area, for the new mental hospital site. Groundbreaking ceremonies held on July 4, 1870, were presided over by Governor Rutherford B. Hayes, but Hayes would be in the White House by the time work was finished. When its doors opened in 1877, the Columbus Lunatic Asylum was said to be the

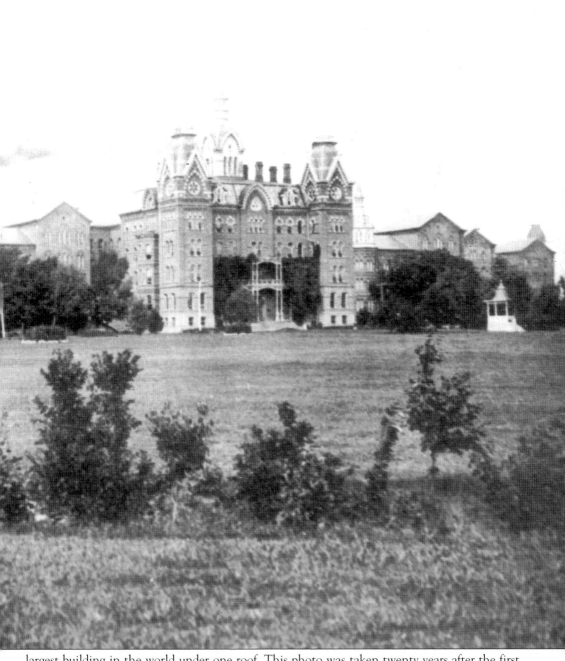

largest building in the world under one roof. This photo was taken twenty years after the first patients were admitted, in 1897. By the 1990s, the crumbling asylum complex had become one of Columbus's darkest landmarks; unrenovated basement cells still contained floor drains, remnants from the days of "water treatment." Closed in the early 1990s, the asylum's 1996 demolition made way for the modern Ohio Department of Transportation buildings.

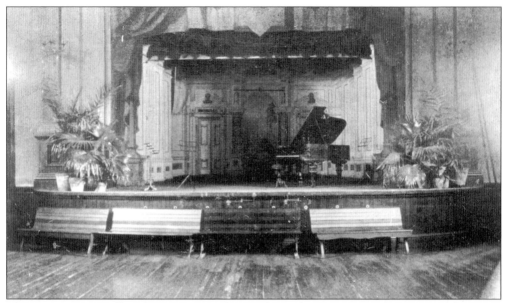

The Amusement Hall at the Lunatic Asylum is shown here in 1900. The more stable among the patients were treated to plays and comedy performances here. Touring vaudeville acts often stopped here when in Columbus. The Amusement Hall was also occasionally used for types of performance therapy.

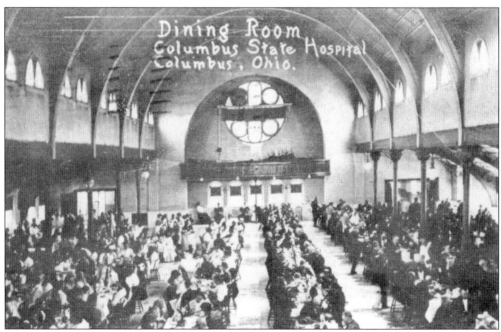

This 1900 photo shows the gigantic asylum dining hall at meal time. Patients were often treated like inmates, and orderlies were a constant presence at meals, acting as guards. They can be seen here seated along the back wall.

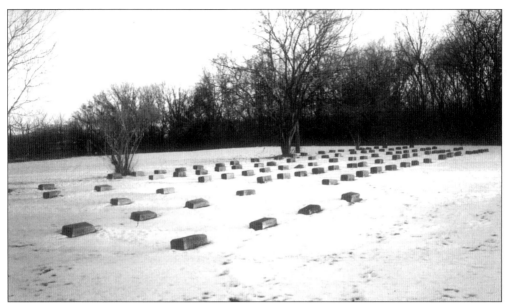

After the 1996 demolition of the Columbus Psychiatric Hospital (as it came to be known), construction began on the Ohio Department of Transportation Headquarters. Left standing was the juvenile detention center TICO, as well as a small outpatient mental health center. In the woods between these buildings and Interstate 70, several artifacts from the old Asylum were left behind: the indigent patient cemeteries.

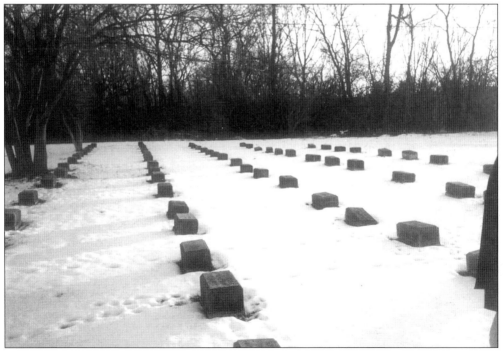

Three cemeteries were left after the Asylum was removed. This is the closest of the three, as it appeared in early 2000. Seventy-five tombstones of identical shape and size occupy the graveyard, all but two engraved simply with a name, a birth date, and a date of death.

The only two tombstones without names bear a single word: SPECIMENS. What is buried here? Remains, perhaps, used in medical classes at the old Asylum? The answer may have gone with the Asylum itself.